CHELSEA
THROUGH TIME
Brian Girling

AMBERLEY PUBLISHING

Acknowledgements

Grateful thanks are offered to Maurice Friedman and Peter Duncan who have kindly allowed the inclusion of images from their collections in this book. Tribute should also be made to the early photographers whose skills now allow us an insight into the everyday scenes observed by our ancestors. These include postcard photographer Edwin Cook of Fulham Road, whose extensive series of local viewcards wonderfully captured the spirit of Edwardian Chelsea.

Books consulted for this compilation include *The Chelsea Book* by John Richardson, *Chelsea Seen from its Earliest Days* by John Bignell and *The Buildings of England, London 3: North West* by Bridget Cherry and Nikolaus Pevsner. Additional research by Ian Vanlint is also gratefully acknowledged.

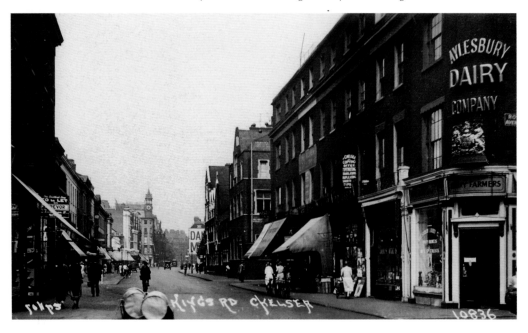

King's Road, *c.* 1912

First published 2015

Amberley Publishing
The Hill, Stroud, Gloucestershire, GL5 4EP
www.amberley-books.com

Copyright © Brian Girling, 2015

The right of Brian Girling to be identified as the Author of this work has been asserted in accordance with the Copyrights, Designs and Patents Act 1988.

ISBN 978 1 4456 3499 9 (print)
ISBN 978 1 4456 3520 0 (ebook)

British Library Cataloguing in Publication Data.
A catalogue record for this book is available from the British Library.

Typesetting by Amberley Publishing.
Printed in Great Britain.

Introduction

The number and diversity of Chelsea's attractions are celebrated far beyond its boundaries. Many will know of its great annual flower show; Wren's imposing Royal Hospital with its Chelsea Pensioners; its splendid Embankment by the Thames; its wealth of historic associations with the arts, its legendary shopping and, of course, its eponymous buns – but these are only part of the story.

This arty slice of west London began as a medieval village on the Middlesex bank of the River Thames, its early houses gathered around the venerable building we now know as Chelsea Old Church. The village's site was a most agreeable one, benefiting from the fresh air the prevailing winds brought in from the river and the fields of Surrey and Middlesex. The Thames brought trade and, away from the river, the fertile land went on to sustain market gardens and nurseries, the last remnants of which survived into the twentieth century.

The great cities of London and Westminster lay downstream, their presence revealed by a smoky smudge in the north eastern sky. Proximity to the capital ensured Chelsea's desirability as a rural retreat for eminent Londoners; from the sixteenth century, great mansions arose, including those of Henry VIII and Sir Thomas More.

A taste of London style came in the early 1700s with the building of grand terraces of lofty town houses in Cheyne Walk and Cheyne Row. The houses embraced the fashionable Georgian designs that had become popular following London's post-fire (1666) rebuilding. With its obvious attractions, Chelsea began to attract a host of luminaries from the world of the arts, including painters Turner, Whistler and Rossetti, dramatist Oscar Wilde, writers Henry James, Bram Stoker and George Eliot, and historian Thomas Carlyle, who set up home in a mellow town house in Cheyne Row. A variety of other artists were beguiled by Chelsea's charms and, with new studio developments, Chelsea was firmly established as London's artistic quarter. To the north, an aristocratic new area called Hans Town took shape from the late 1700s.

While Chelsea remained 'in the country', lavish pleasure grounds at Ranelagh and Cremorne attracted crowds of fun-seeking Londoners. These were effectively the theme parks of the day.

The main urbanisation of Chelsea was a product of the 1800s, as market gardens gave their sites for handsome new streets and garden squares while London spread ever westwards. In the grandest of these, town mansions by Norman Shaw and others added to the richness of Chelsea's architecture.

Despite the opulence of much of Chelsea, pockets of slum property also existed – a London characteristic. The worst of it was replaced by estates of 'model dwellings' early in the 1900s, but industrialisation of the riverside along Lots Road and beyond caused pollution, which lost Chelsea the clean air it had once enjoyed.

Chelsea's most famous street is King's Road, once the private reserve of the sovereign. From 1830, the public was allowed to use it and it quickly evolved as Chelsea's 'high street,' with domestic stores that provided an alternative to the village shops near the river. It later developed as a centre of entertainment as a profusion of 'electric palaces' caught the cinema-going craze of the early 1910s.

As Chelsea became ever more 'Londonised', links with the capital improved – the Underground arrived in 1868 and, in 1874, Chelsea Embankment replaced a picturesque jumble of wharves and jetties but gave a new direct road route into the heart of Westminster.

In 1900, Chelsea became a Metropolitan Borough within the County of London, and, in 1965, amalgamation with neighbouring Kensington created the Royal Borough of Kensington & Chelsea.

The 1960s brought a new mood to Chelsea, with the rainbow hues of gentrification spreading through the side streets that post-war austerity had left in a drab state. King's Road blossomed anew and was bright with trendy boutiques, coffee bars and restaurants. Chelsea's arty teenagers embraced the new fashions of the day and King's Road was a virtual catwalk of the latest 'gear'. The shops became ever more sophisticated in the final years of the 1900s and can now offer some of the smartest shopping in London.

A stroll around Chelsea in the present day will reveal a profusion of 'blue plaques' adorning the houses of illustrious former residents, but their stories have been told elsewhere. This book focuses instead on the changing faces of Chelsea from Victorian and Edwardian times, and the 1960s as recorded by the photographers of the day, with modern comparison images alongside.

The book also celebrates a wonderfully characterful area of the capital and it is hoped that those who know and love Chelsea will find much to interest them.

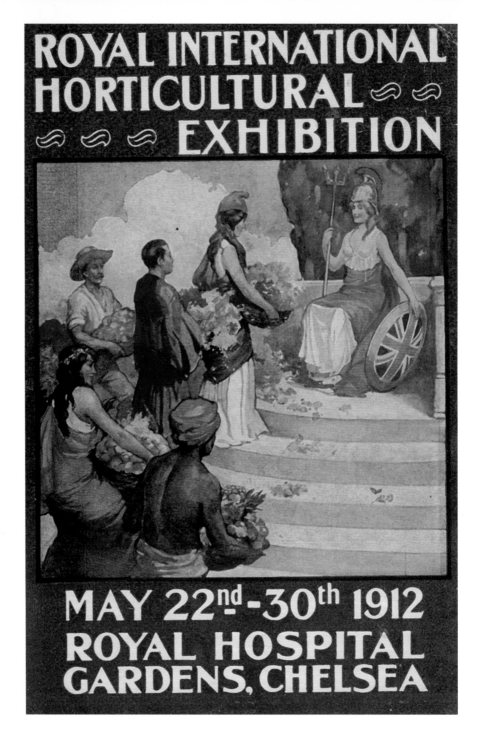

ROYAL INTERNATIONAL HORTICULTURAL ❧ ❧ ❧ ❧ ❧ EXHIBITION

MAY 22nd-30th 1912 ROYAL HOSPITAL GARDENS, CHELSEA

A major event in London's social calendar, the Royal Horticultural Society's annual show was originally staged in the Inner Temple Gardens, City of London in 1888. Increasing popularity led to a move to more spacious grounds of the Royal Hospital, and in 1912, the society mounted the first Chelsea event: Royal International Horticultural Exhibition. It was followed in 1913 by the first Chelsea Flower Show. This fine patriotic postcard publicising the forthcoming event was one of several issued in 1911.

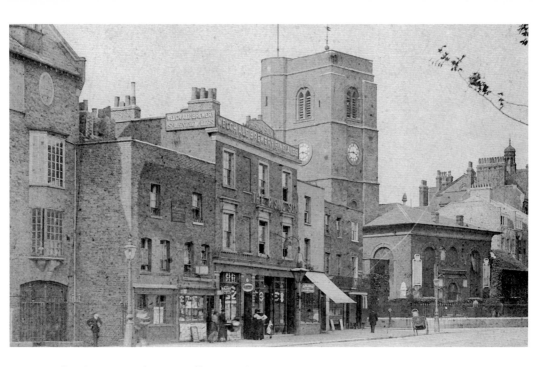

Lombard Terrace, Cheyne Walk, *c.* 1906
Chelsea Old Church is seen in Edwardian days when it had still retained something of its original village setting. Much of this had been lost in 1874 when the Chelsea Embankment was built, a process that involved the removal of all the houses and wharves that backed onto the River Thames. All that was left here was Lombard Terrace, formerly the north side of old Lombard Street, and its western continuation, Duke Street. A surviving remnant of the old village was the Rising Sun pub, whose hanging lamp can be seen next to the shop blind.

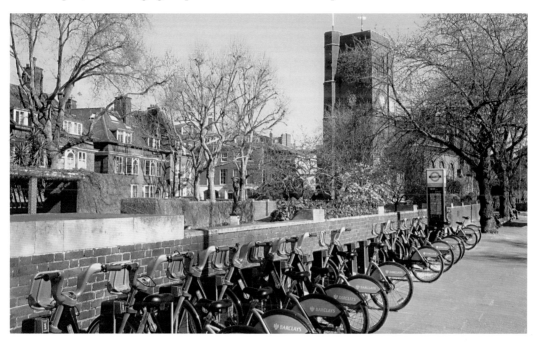

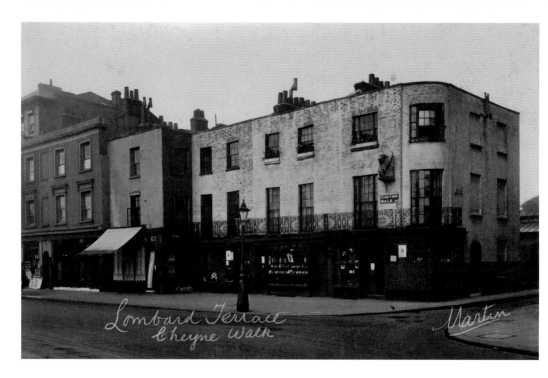

Lombard Terrace, Cheyne Walk, *c.* 1925

In this later view, several of the domestic stores seen earlier had been replaced by bookshops and there were artists living upstairs. One of the houses contained a studio where sculptor Jacob Epstein worked – a carving by him is on display in the sunken garden that replaced the houses after the war. The Rising Sun pub is again seen next to the shop with the sunblind; next to it an archway led into the long lost Sun Court.

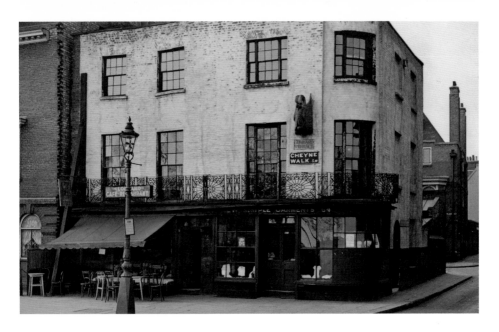

Café in Lombard Terrace, Cheyne Walk, *c.* 1935

Something of the essential spirit of old Chelsea is preserved in this view, in which the Lombard Café provided rare (for 1930s London) outdoor tables and chairs from which local artists and others could observe the passing scene and appreciate the effects of the light on the river. However, subsidence was affecting the old building in its final years and only it and its neighbour on the Old Church Street corner were left – the last of old Lombard Street. The Second World War saw the end of the row including the later houses, and after years of dereliction, a sunken garden was created out of the house's former basements and cellars. Roper's Garden was opened in 1965.

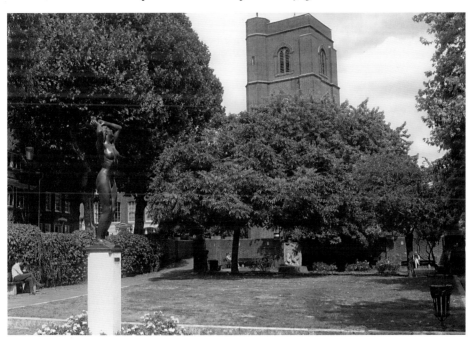

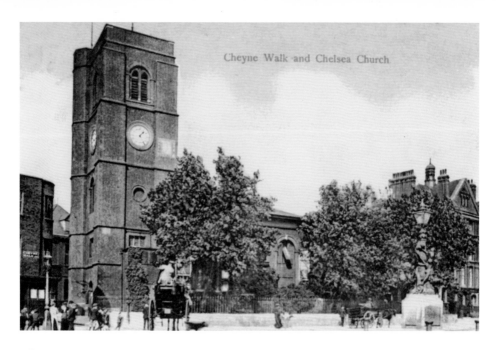

Cheyne Walk and Chelsea Church

All Saints, Chelsea Old Church, c. 1905

The church has graced Chelsea's riverside since at least the thirteenth century, the design of the building we see today being that created from 1667–74 when the church was rebuilt in brick. However, the modern image shows a recreation of the church as restored from 1949–58, following the destruction of the original during an air raid in 1941. The church's meticulous restoration included the repair and replacement of its remarkable assembly of monuments, including that of Sir Thomas More dating from 1532. While the old tower had been totally destroyed, ancient parts of the building from the fourteenth and fifteenth centuries survived, and a sundial dated 1692 was restored to the rebuilt tower.

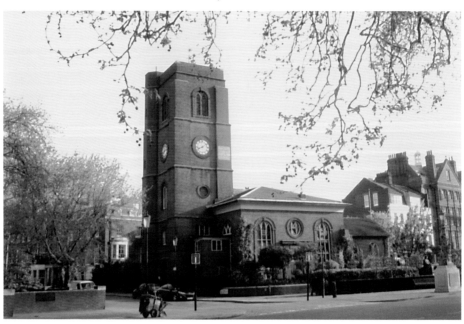

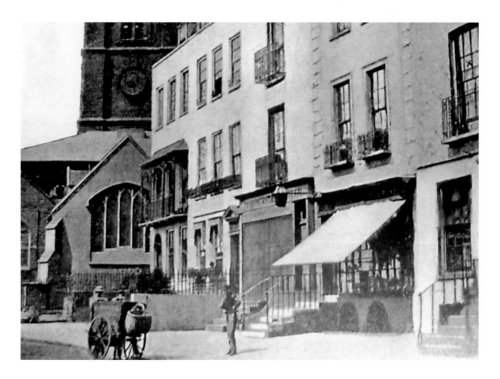

Prospect Place, Cheyne Walk, c. 1870s
This row of shops and houses between the Old Church and Lawrence Street (built in 1686) included a coffee house, and in a foretaste of medical care on this site, a chemist's shop. The Cheyne Hospital for Sick and Incurable Children was founded in 1875 and rebuilt in 1889; a day centre for the training of spastic children began here in 1955. Following the closure of the hospital, the building took on a new residential role and is now known as Courtyard House.

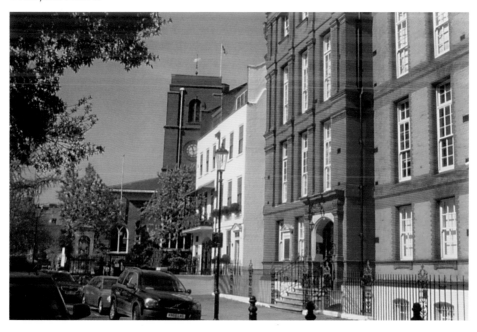

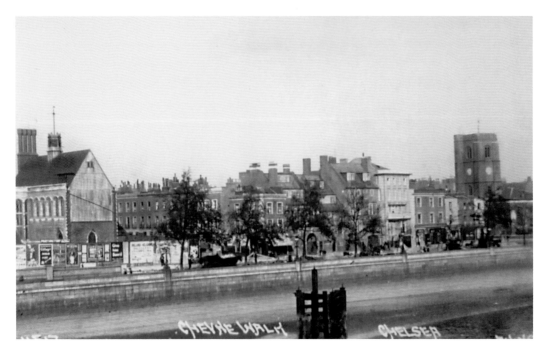

The Chelsea Waterfront from Battersea Bridge, c. 1914

The view above shows Crosby Hall (*left*), the medieval mansion that was removed from Bishopsgate and reassembled here from 1909/10. A later part of the complex housing the British Federation of University Women would not arrive until 1927. The subsequent departure of the ladies brought Crosby Hall back into private ownership and opened the way for the creation of a magnificent new building in the style of a Tudor palace.

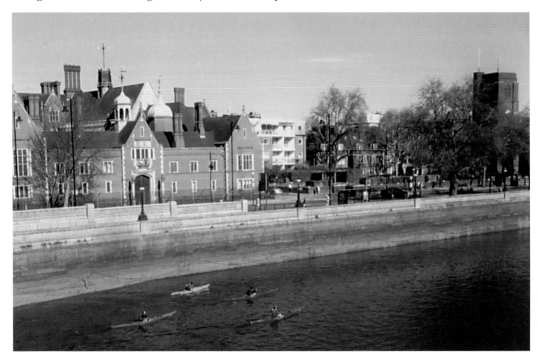

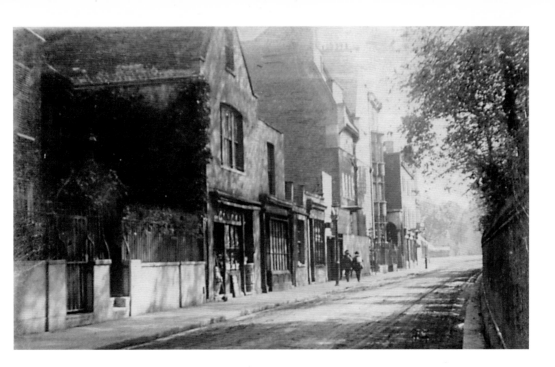

Cheyne Walk, *c.* 1900

Cheyne Walk is the historic Chelsea riverside, its houses once separated from the Thames by a narrow roadway and a row of trees before the building of the Embankment pushed the river away. Even so a village atmosphere lingered on, as shown here with aged houses and modest shops including those of a fruiterer, cycle repairer and artists' studios. The riverbank trees were replaced by the leafy Embankment Gardens, but a more urban look came in the 1930s when new flats called Shrewsbury House were built on the site of the old Chelsea mansion of the same name.

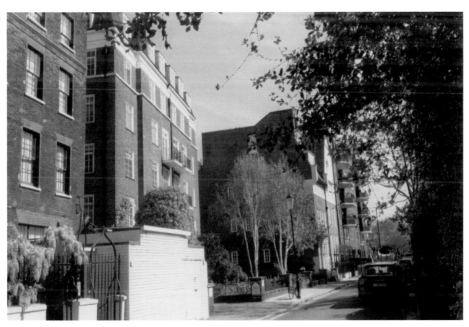

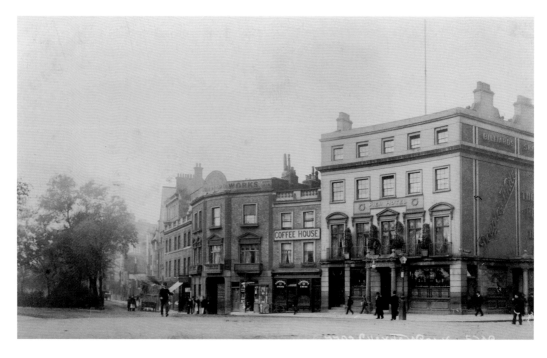

The Pier Hotel, Cheyne Walk by Oakley Street, *c.* 1906
In a particularly tragic planning disaster, the scenic and historical approach to Chelsea from Albert Bridge was replaced in 1968 by a block of flats. The lost buildings included the Pier Hotel (1844) and adjoining premises, including Henry Job's former coffee rooms, and further along the artist-haunted Blue Cockatoo Café. An archway led into a yard and the premises of billiard table makers Thurston & Co. Established in 1799, it moved to Cheyne Walk in 1857.

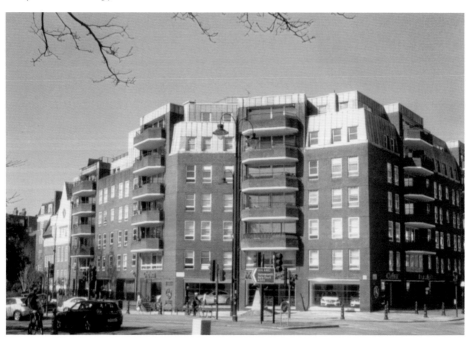

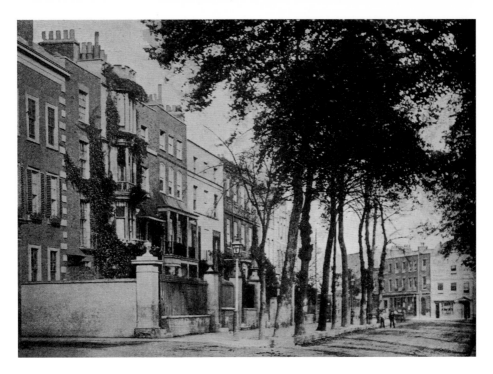

Cheyne Walk by (Chelsea) Manor Street, 1860s

The section of Cheyne Walk that is east of Oakley Street is distinguished by its terraces of tall town houses, the construction of which began around 1717. The houses are rich in their associations with artists, writers and other luminaries who appreciated the spectacular views of the river from their windows. Many original houses remain, but a few were rebuilt by Chelsea Manor Street in a grander style, as can be seen here. Distant Queen's Road West (Royal Hospital Road) is seen within a long lost shopping row and a pub.

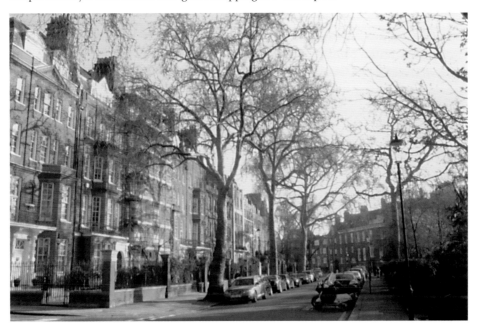

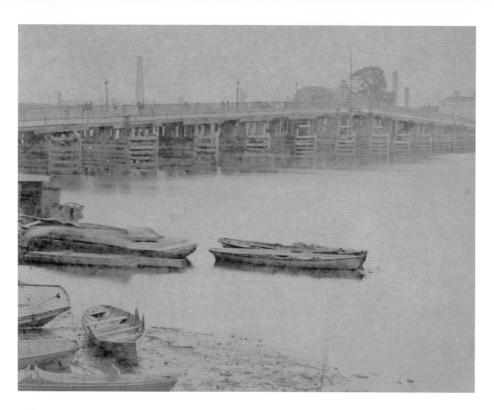

Old Battersea Bridge, c. 1875

The first bridge to link Chelsea with the Surrey shore came in 1772, when this ramshackle wooden structure replaced a ferry. The bridge served Chelsea well until 1890, when a new cast-iron bridge by Sir Joseph Bazalgette replaced it. This became the only bridge in Chelsea to accommodate electric trams – their terminus was in Beaufort Street by King's Road.

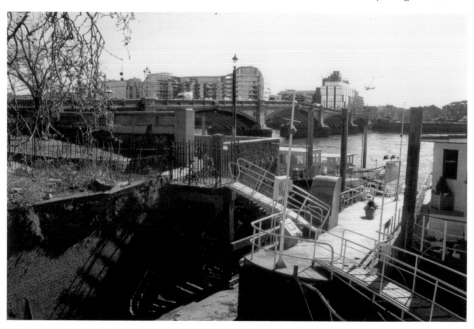

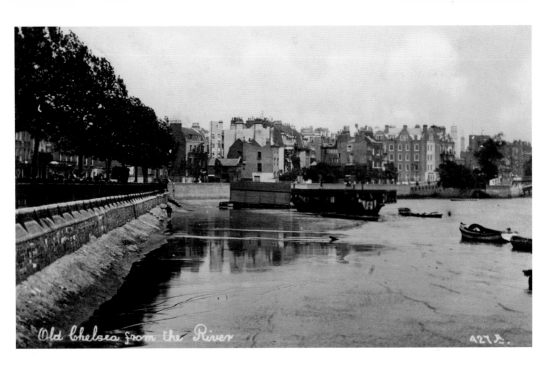

The Houseboats, Lindsey Wharf, Cheyne Walk, c. 1906
The tidal Thames is subject to strong currents, but at this sheltered area there is a placid haven along the foreshore, which early maps mark as 'mud'. It was here that a picturesque colony of houseboats grew up in the twentieth century to give an ongoing reminder of Chelsea's maritime past.

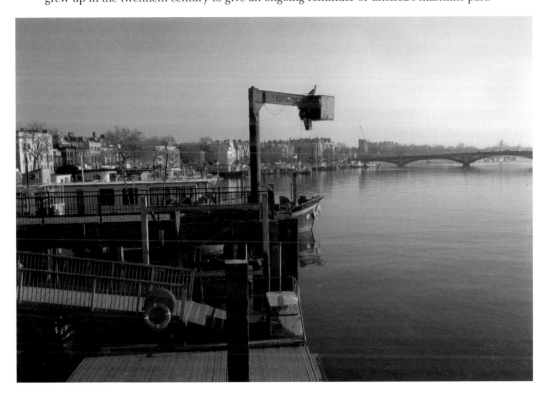

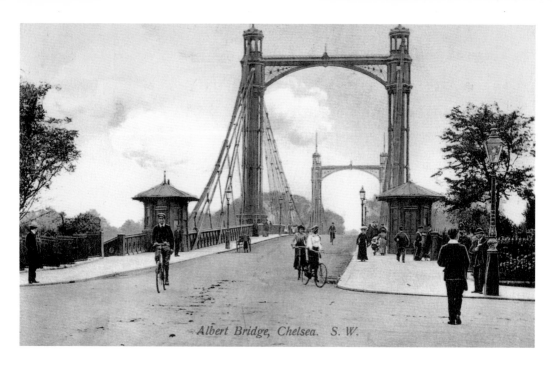

Albert Bridge, Chelsea. S. W.

Albert Bridge, c. 1906

This is the 'trembling lady' of the Thames; fragile and beautiful, it marks the midway point of Chelsea's riverside. The bridge's vulnerability repels overweight road traffic (it was built in the age of horse-drawn vehicles), and marching soldiers are traditionally obliged to break step when crossing, despite the later addition of a support beneath its longest span. The bridge opened in 1873.

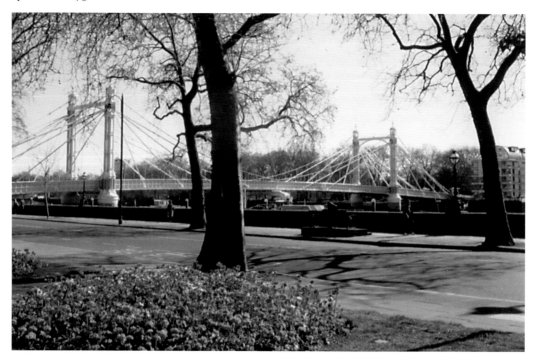

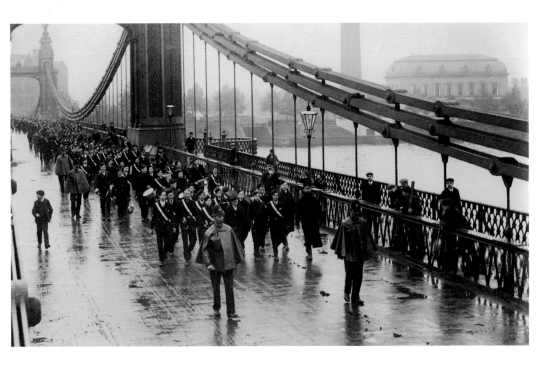

Chelsea Bridge, c. 1910
The first Chelsea Bridge was constructed in cast iron and opened in 1858, at what was once thought to have been a fording point on the river. Designed by Thomas Page, it remained a toll bridge until 1879, but a new, stronger replacement, which was better able to cope with modern traffic, came in 1937.

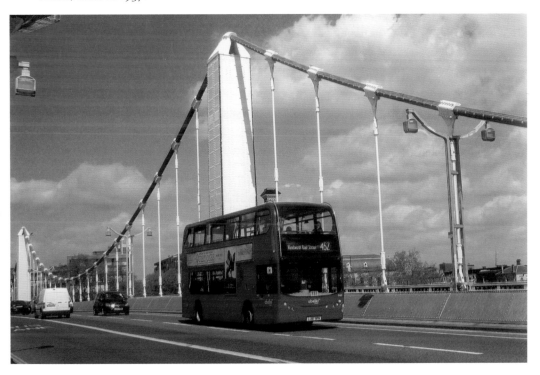

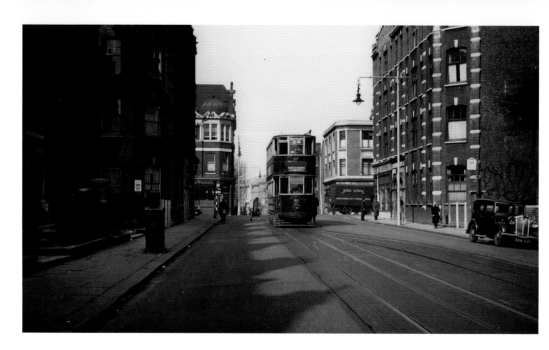

Chelsea Tram Terminus, Beaufort Street by King's Road, *c.* 1948

Chelsea was one of several Metropolitan Boroughs that resisted the spread of London's electric tram system and it was not until 1911 that a short line penetrated its boundaries by crossing Battersea Bridge and running up part of Beaufort Street to terminate at King's Road. The service linked up with the vast South London tramway network – the car seen here was preparing to run to Blackfriars via Camberwell. The route (No. 34) was withdrawn in 1950 following a shipping accident that weakened Battersea Bridge – the trams then terminated at the bridge's Battersea side.

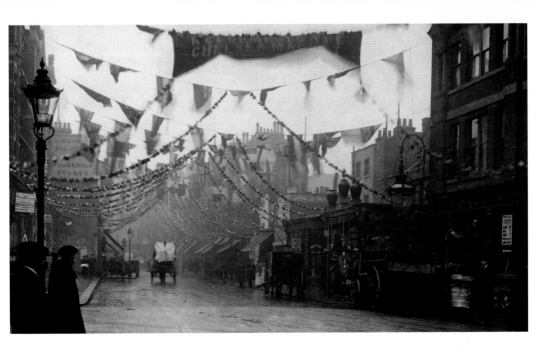

King's Road by Beaufort Street, *c.* 1911

The famous King's Road originated as a private road for royalty speeding their journeys between Westminster and the palaces at Kew and Hampton Court. It became a public road in 1830 and as the area gradually lost its rural character, the road effectively evolved as Chelsea's 'high street'. Modest shops, seen here beyond the Roebuck pub, were built in the former front gardens of older houses – one of them was a purveyor of an old cockney dish, Eel Pie. King's Road is seen here 'en fete' with a banner reading, 'Welcome to the Chelsea Market'.

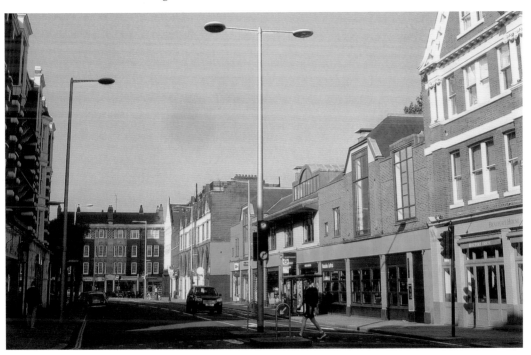

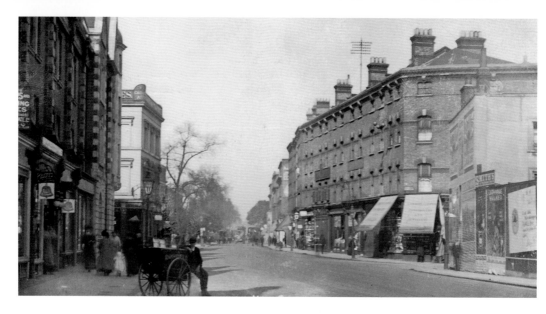

King's Road, Eastwards from Church Street, c. 1905

Edwardian King's Road was a popular centre of entertainment; the site of its most enduring cinema is seen on the right. The lowly building (*right*) was T. H. Harrison's, the lime merchants, but in 1910, the Palaseum, a roller skating rink, opened here. However, the new craze of cinema-going soon caught up with it and, in 1911, the King's Picture Playhouse began attracting the crowds. Many name changes followed, but it will be remembered by many as the Essoldo. A break came from 1973–79, when as the King's Road Theatre it presented the *Rocky Horror Show,* a popular stage musical. It is now a multi-screen cinema.

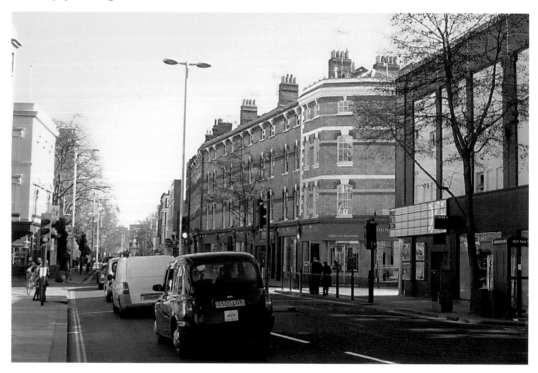

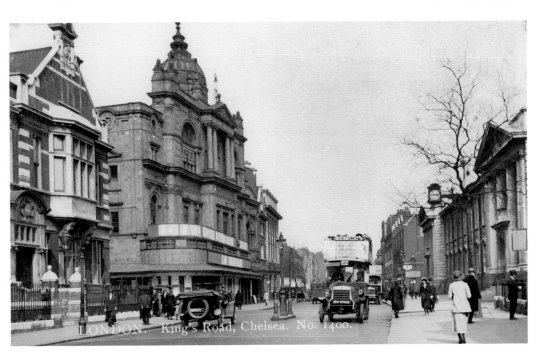

The Chelsea Palace of Varieties, King's Road by Sydney Street, *c.* 1920

King's Road's grandest place of entertainment was this Edwardian extravaganza. Terracotta clad and designed by Messrs Wylson and Lang, it opened in 1903. Vesta Tilley, Gracie Fields and Harry Lauder were among the theatrical notables to tread its boards and the Christmas pantomime was an annual delight for Chelsea's younger elements. The old pleasure palace closed in 1957, and after spending some years as a television recording studio, it was demolished in 1960; a furniture store replaced it. To the right is Chelsea Town Hall, which opened in 1908 while retaining parts of the earlier Chelsea Vestry Hall.

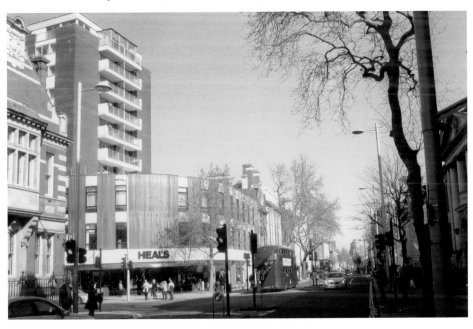

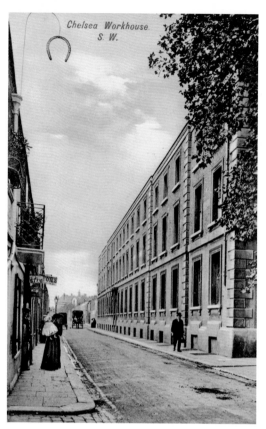

Chelsea Workhouse.
S. W.

Chelsea Workhouse, Arthur (Dovehouse) Street, c. 1906

We look upon Chelsea now as a wealthy place, yet in former times pockets of poverty existed and its Victorian workhouse played its part in the lives of the poor during those times. Arthur Street was also a road of modest pretensions and in Edwardian times supported a range of small commercial enterprises, including a beer house, a coal dealer and, seen here beneath a hanging horseshoe, the premises and forge of smiths and farriers S. Margrie & Son. The Margries' business moved to Arthur Street in 1880 and survived there until the whole terrace was replaced by smart town houses and part of a rebuilt Chelsea fire station in the 1960s.

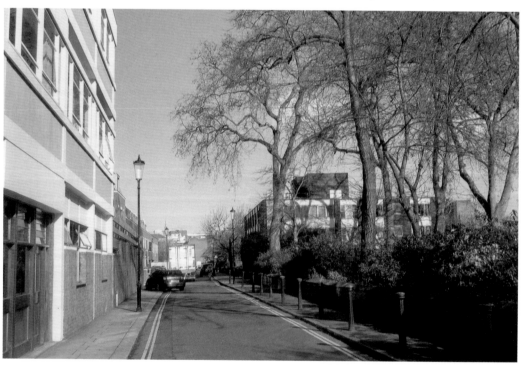

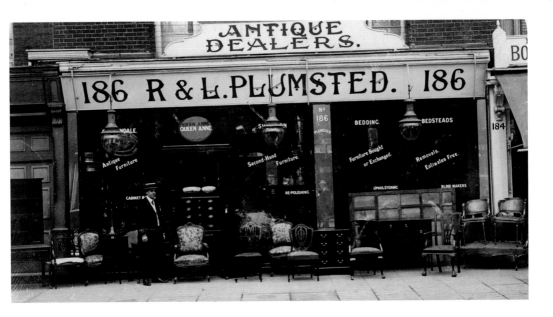

No. 186 King's Road, c. 1907

The changing character of King's Road in the 1930s as a terrace of small shops gave way to Chelsea's only super-cinema, the Gaumont Palace, which opened in 1934 with a capacity for 2,502 patrons. One of the larger shops on the site was that of antique dealers and household furnishers R. & L. Plumsted, whose stock spilled out onto the pavement in the display seen here. The Gaumont lasted until 1972, when much of it was given a new life as a Habitat store behind its listed façade. However, a small cinema on the site maintains the heritage.

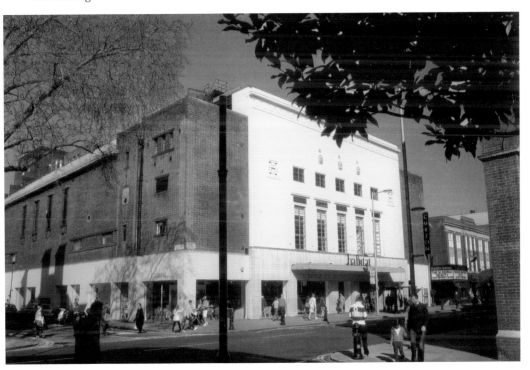

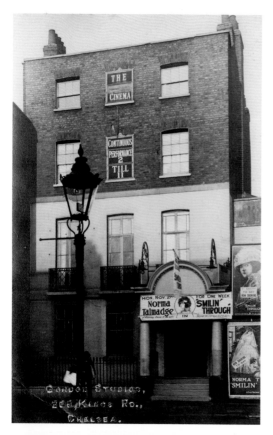

The Cinema, No. 180 King's Road, *c.* 1914
In the days before the dazzling modernism of the Gaumont Palace illuminated King's Road, a far more modest enterprise capitalised on the burgeoning craze for moving pictures or 'animated photographs' as they were sometimes called. An early phenomenon of those times involved the conversion of a variety of existing buildings for the showing of movies, as seen here where an old town house took on its new role. Name changes came in quick succession; in 1911 it was the Chelsea Electric Palace and, in 1912, the Cadogan Electric Palace. With new purpose-built cinemas coming along, this one soon faded away and a new shopping terrace followed its demolition.

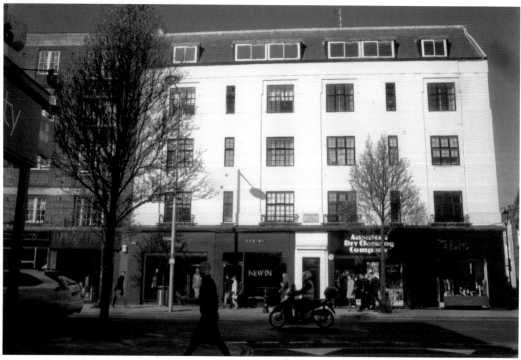

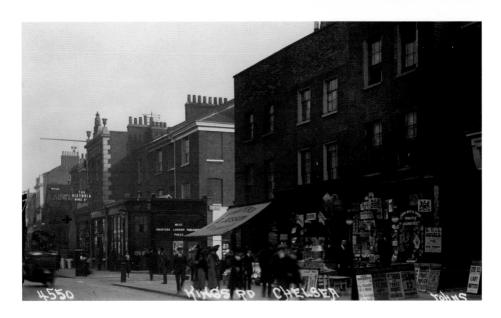

King's Road by Shawfield Street, c. 1912

Clutter was king at this trio of domestic stores, the central one being Henry Monk's hardware emporium. No one could have guessed then that this address would later evolve into one of King's Road's more iconic institutions, the Barbieri family's renowned coffee shop and café, the Picasso. Celebrities, including members of the Rolling Stones, Eric Clapton and other rock-and-rollers, were drawn to the Picasso. In the 'swinging sixties' and later, its open front made it a favourite from which to observe the passing parade of Chelsea's fashionably clad bright young things, while the café's ambience made it a good meeting place for Chelsea regulars. Many mourned the passing of the Picasso in 2009 when changing times brought about its closure.

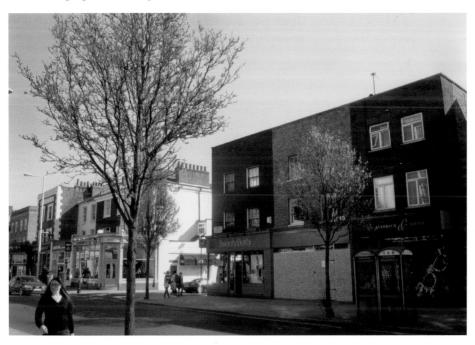

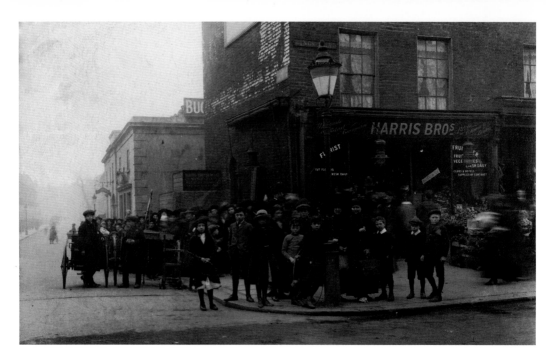

Harris Bros, Greengrocers and Fruiterers, No. 125 King's Road, 1917
An acute potato shortage during the First World War led to scenes like this at any greengrocers in London who were fortunate enough to receive a supply. Here two policemen were on hand to control the crowds, but the local children found the cameraman a more interesting prospect. The gas lamp seen here is partly masked at a time when night-time air-raids by Zeppelins were a constant threat. The hardware shop that would become the Picasso is on the right.

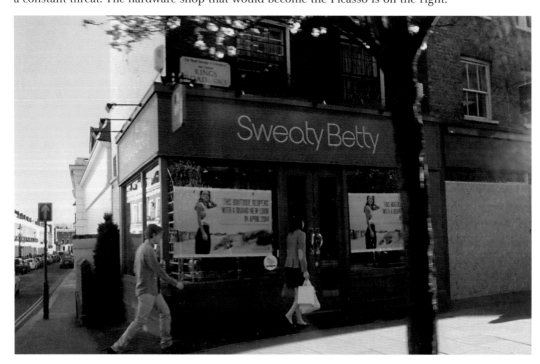

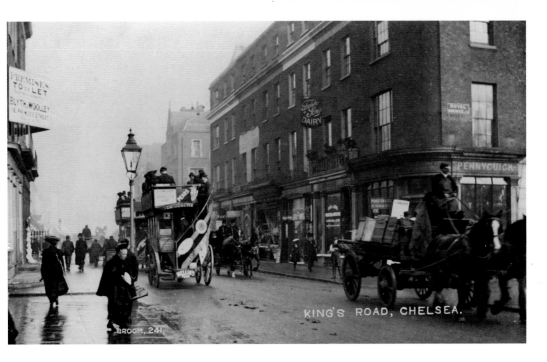

Soho Records, No. 125 King's Road by Shawfield Street, *c.* 1969

The same group of shops, but it is the 1960s and the long-standing fruiterers have departed, leaving a legacy of their time here high on the Shawfield Street corner. Now, however, it was time to celebrate the popular music of the day and, in that pre-digital age, vinyl ruled the roost and the latest Beatles LP 'Abbey Road' was on sale within. Next door, the Picasso with its bright canopy was enjoying early success, and beyond, the former Temperance Billiard Hall was awaiting conversion into Antiquarius, an antique dealers' market with 120 stands.

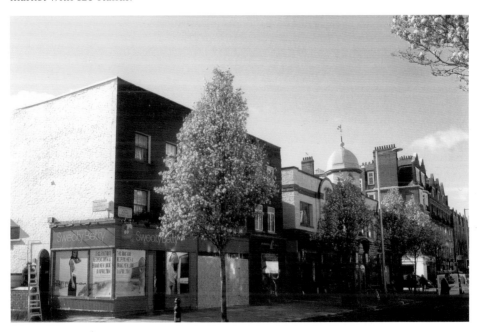

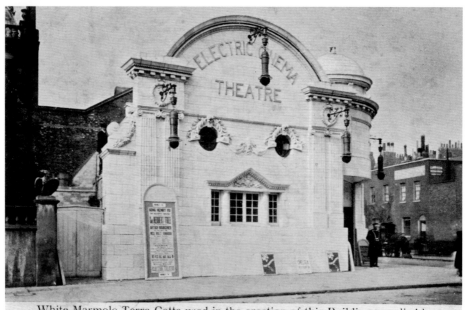

White Marmolo Terra Cotta used in the erection of this Building supplied by
Shaws Glazed Brick Co, Ltd. Darwen. Lancs.

Photo Inglis. Chelsea.

The Electric Cinema Theatre, King's Road by Markham Street, c. 1913
With its gleaming white tiles and bright electric lights, the arrival in 1913 of this new
cinema made a dramatic contrast to the sober gas-lit façades of King's Road. Few will
remember the cinema when it looked like this, but for many this was The Classic to which
modernisation in 1937 gave a new frontage. The cinema closed in 1972. Next door was the
Pheasantry with its arch, quadriga and caryatids. In a long and varied history, it found
fame in the 1930s as an exclusive club and restaurant.

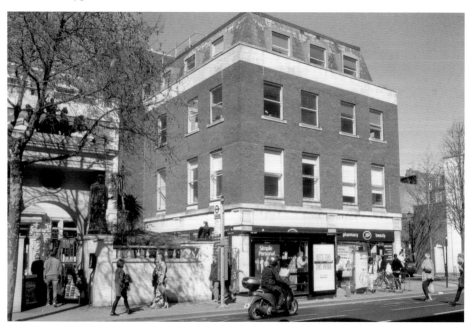

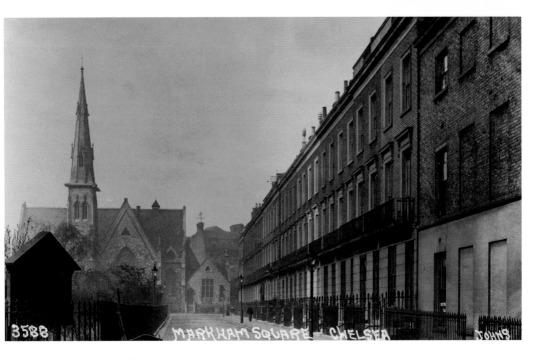

Markham Square from King's Road, *c.* 1909

King's Road was mostly built up at a time when living in a London garden square was becoming fashionable – Markham Square (*c.* 1836) was one of several that led off the main road. The usual pattern differed slightly here in that there were only houses on two of its sides; King's Road took a third side, while the fourth was occupied by Chelsea Congregational Chapel. The chapel was demolished in 1953 with new houses taking the site.

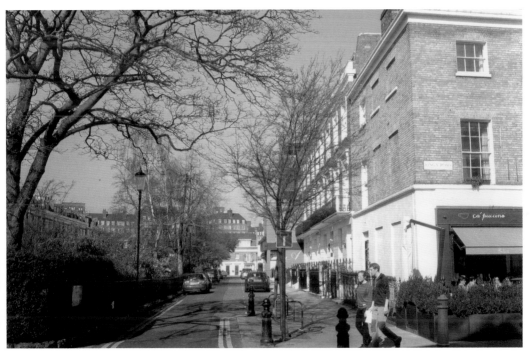

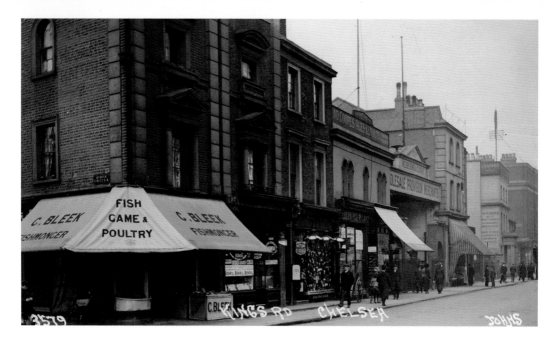

King's Road by Bywater Street, *c.* 1910

A range of old King's Road businesses on view here, including those of Charles Bleek, fishmonger, and Webb, Sons & Clarke, cheesemongers at No. 124. Their imposing pedimented building was once an entrance to Ranelagh Works, an old industrial complex. Further down, the premises of sanitary engineers Thomas Crapper can just be seen. This famous old firm specialised in decorated sanitary ware and was responsible for installations at Windsor Castle and Sandringham. Their showroom closed in 1966 and new shops covered the site thereafter.

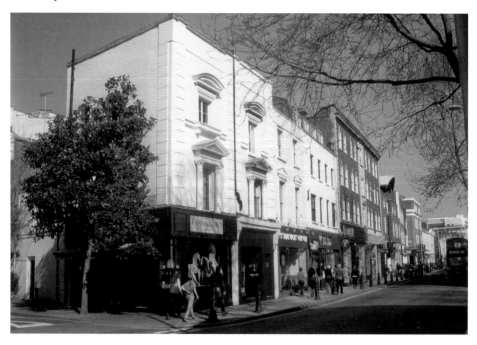

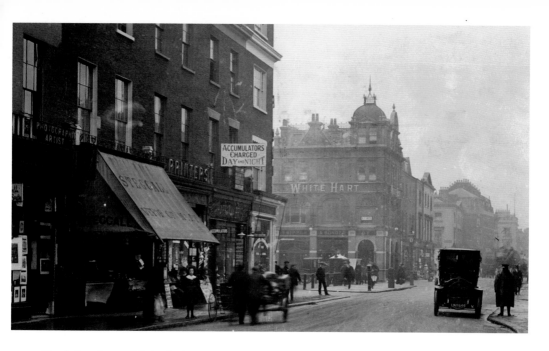

King's Road near Walpole Street, *c.* **1905**

More of King's Road's extensive shopping facilities in Edwardian times, with a row running up to Royal Avenue where the White Hart pub adorns the further corner; this is a now a McDonald's restaurant. On the left is the shop and studio of photographer Frank Hill, whose works fill the window. A sign, 'Accumulators charged day and night', highlights the growing use of electricity at that time.

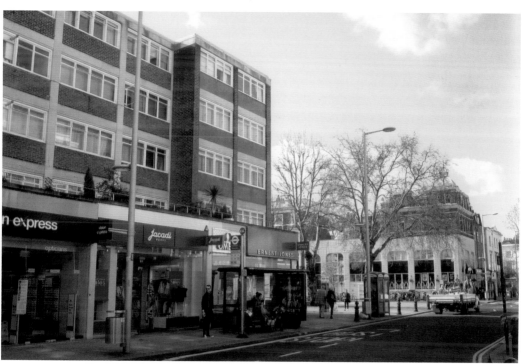

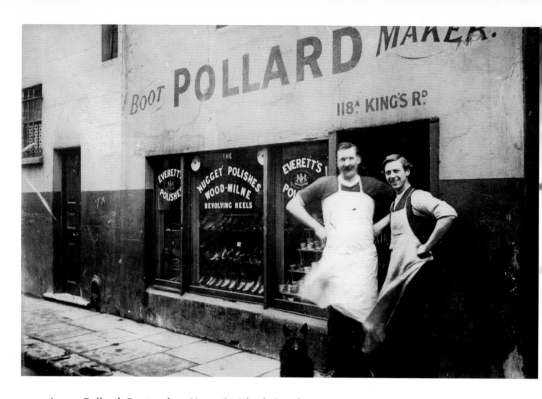

James Pollard, Bootmaker, No. 118a King's Road, c. 1910
These tiny premises were not actually in King's Road, but around the corner in Keppel Street (now Tryon Street). The business was typical of many small craftmens' enterprises in Chelsea; this one lay behind the King's Road shop of Hyman Bloomberg, tailors. Here the workers pose for their photograph, ably supported by the firm's dog.

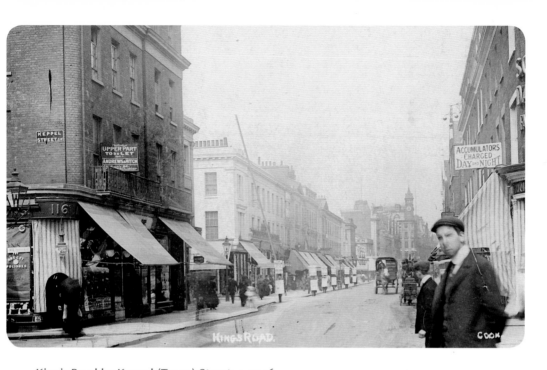

King's Road by Keppel (Tryon) Street, c. 1906

Many of these buildings remain familiar, but to the left Keppel Street still displayed its old name plate before the change was made to Tryon Street. Further along by Anderson Street, a distant line of six sandwich men proclaims the delights of Frank Traylen's fancy drapery shop. This was a major retailing outlet in Edwardian King's Road.

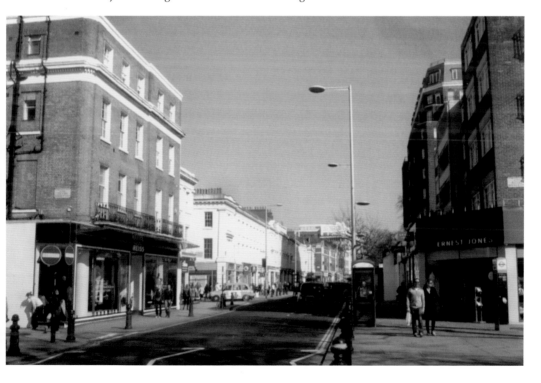

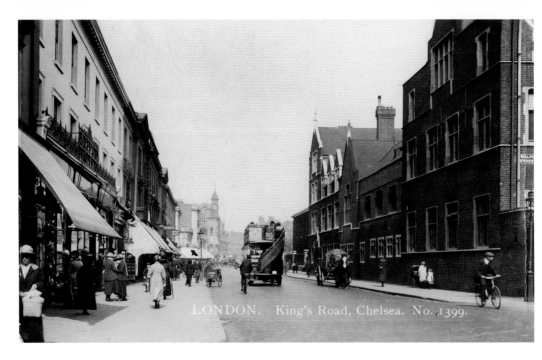

LONDON. King's Road, Chelsea. No. 1399.

King's Road and Whitelands College from Anderson Street, *c.* 1925
To the right by Walpole Street is Whitelands College, a teacher training school set up in 1842. It moved away to Putney in 1931 and the site was then taken for the flats of Whitelands House. King's Road is seen with its shoppers in their 1920s fashions and the bus is working the familiar route 19. However, with gas lamps and a horse-drawn delivery cart, the nineteenth century has not been entirely banished.

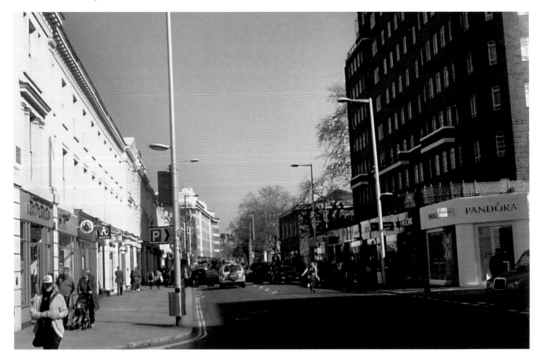

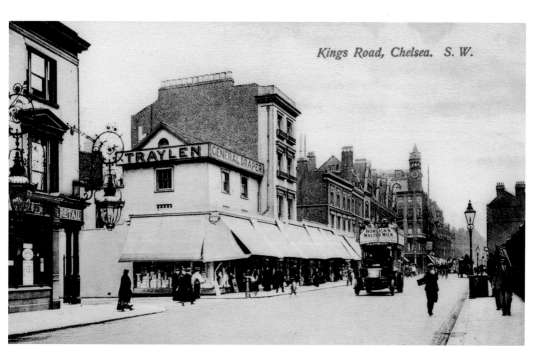

King's Road by Blacklands Terrace, *c.* 1906

King's Road is fortunate in that most of its rebuilds have been on a modest scale, thus maintaining the essential atmosphere of the street. Here, for example, a renewal in the late 1920s removed a ragged assortment of properties including those occupied by fancy draper Frank Traylen, whose prominent lettering ensured that his shops were not missed by the passer-by. The Traylen shops are protected by sunblinds, while on the left by Blacklands Terrace, the Colville Tavern sports opulent pub lamps. The motorbus hints at the future, but at this early date buses did not carry route numbers.

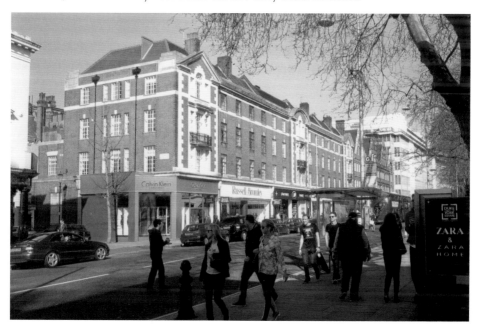

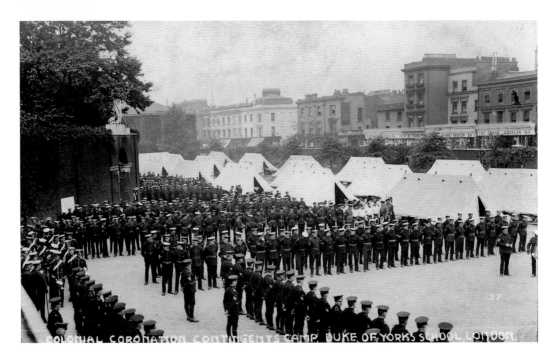

The Royal Military Asylum, the Duke of York's Headquarters, 1911
This Chelsea landmark was built from 1801–03 to provide education for the children of soldiers' widows. It survived until 1909, after which it became the London HQ of the Territorial Army. The view here is of the North Playground, which was used as a camp for colonial soldiers at the time of King George V's Coronation. Following the territorial's departure, a new project in 2003 created Duke of York Square, a fine new public space graced by stylish shops, restaurants and water features.

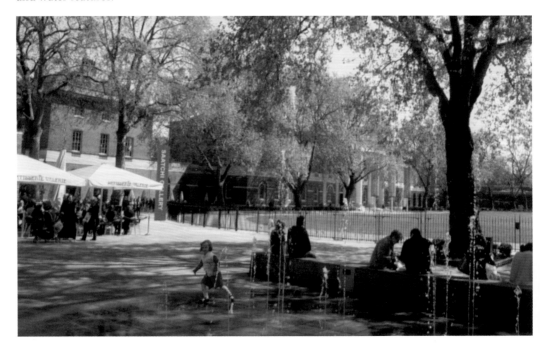

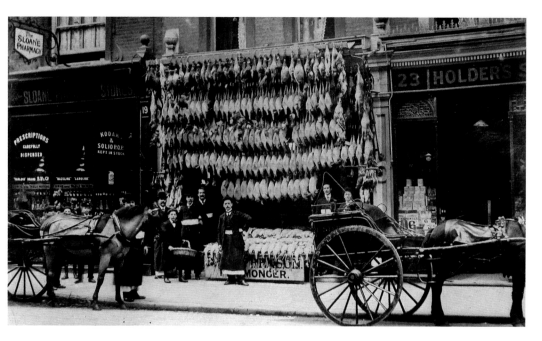

Robert Stephenson, Fishmonger and Poulterer, No. 21 King's Road, *c.* 1908
Two images that show how the domestic stores of former times have been transformed into the smart shops of the present day, a typical process in the ever more fashionable King's Road. Here, Mr Stephenson, his staff and carts for the local deliveries stand by an epic display of produce. In the days before electric refrigeration, displays like this were commonplace, as a quick turnover was essential to maintain freshness, although dust from the street was a potential hazard (*image courtesy of Peter Duncan*).

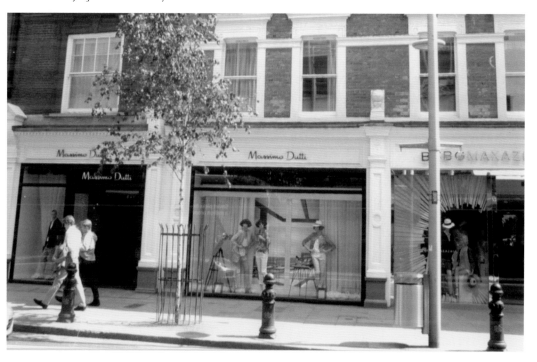

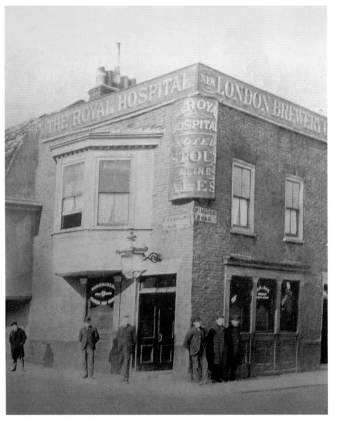

The Royal Hospital Tavern, Franklins Row by Pimlico Road (Royal Hospital Road), *c.* **1900**
King's Road did not begin to develop properly until it became a public highway in 1830, but, by contrast, Chelsea's other route from Westminster to the riverside village was longer in public use and this was reflected in the antiquity of the buildings that once lined it. Variously called Queen's Road, Paradise Row and, at this point, Pimlico Road, we now know it as Royal Hospital Road. As it increasingly became a smart place to live, the picturesque reminders of a semi-rural past were swept away.

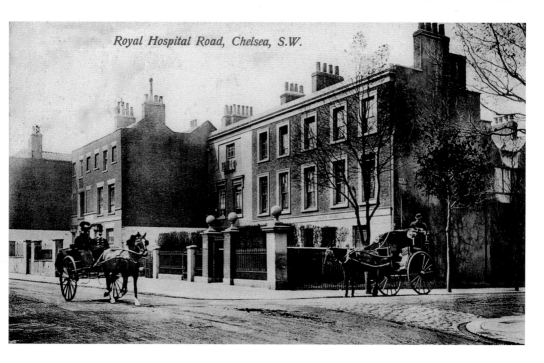

Royal Hospital Road, Chelsea, S.W.

Royal Hospital Road (Cheyne Place) by Tite Street, *c. 1906*
Another pair of images that show how the Queen's Road of old with its modest properties changed into the super smart highway we know today. The older scene is typically Edwardian with its hansom cab at rest between fares; in 1906, hansoms still had some years of life in them, although motorised cabs were beginning to replace them.

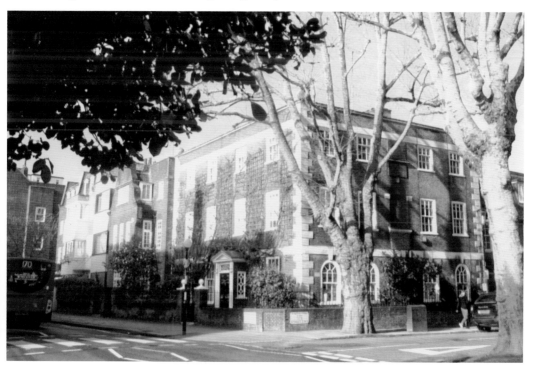

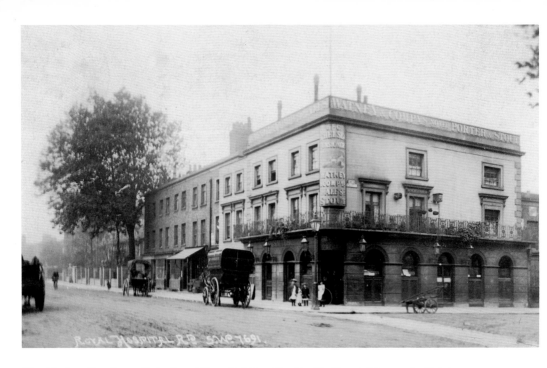

The Chelsea Pensioner Pub, Royal Hospital Road by Smith Street (Ormonde Gate), *c.* 1904
A profusion of pubs along Royal Hospital Road was much appreciated by the Pensioners at the Royal Hospital close by – this corner example was aptly named. There were once many more shops in the street than in the present day, and here a terrace of them is seen running along to historic Paradise Row. In a much-changed scene, the tree has remarkably survived.

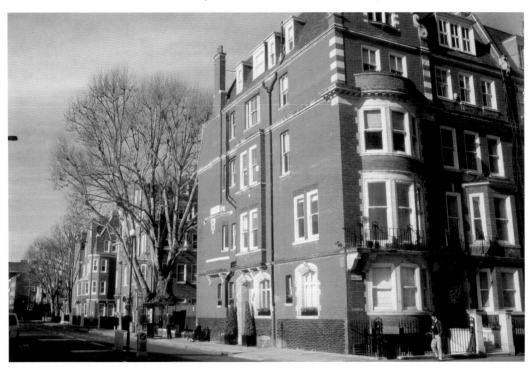

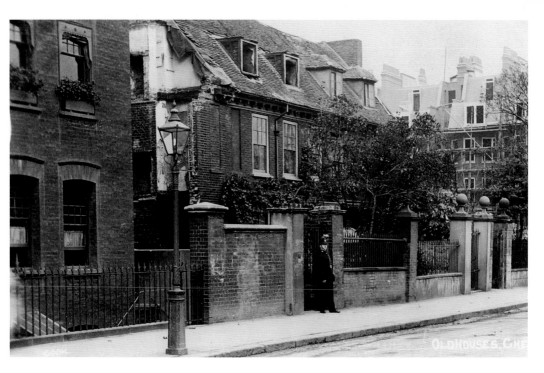

The Last of Paradise Row, Royal Hospital Road, *c. 1905*
Edwardian historians loudly deplored the loss of this row of country cottages as new housing replaced the rustic antiquity of old. The houses of Paradise Row dated from the 1690s and were the last of their kind hereabouts.

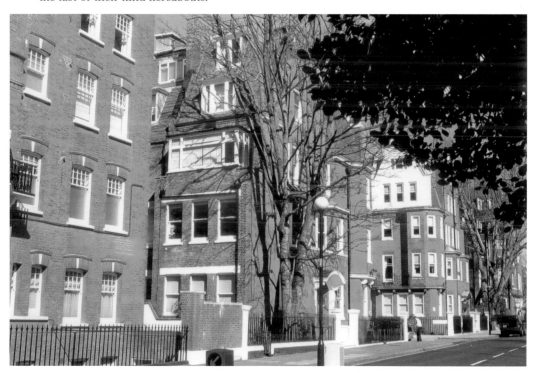

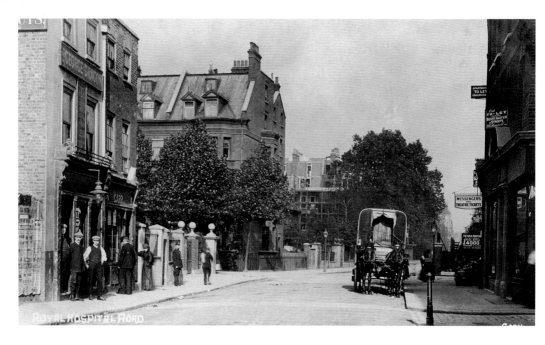

Royal Hospital Road from Paradise Walk, *c.* 1905
More of this street at a time of change as historic buildings gave way to grander new housing.
On the left was the George & Dragon, possibly Chelsea's smallest pub, but the advancing tide of
new building further along signalled that here too the end was nigh. On the right by Tite Street,
a board was part of a fundraising project by the Victoria Hospital for Children, which needed
£4,000 for new building works.

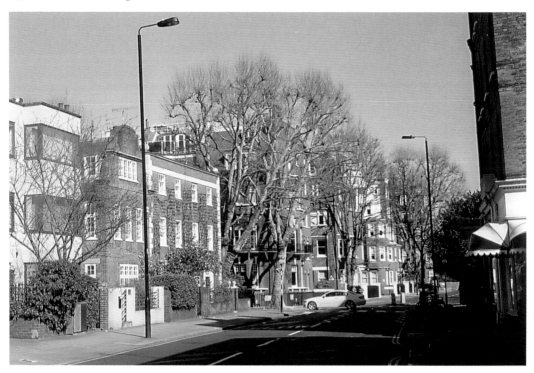

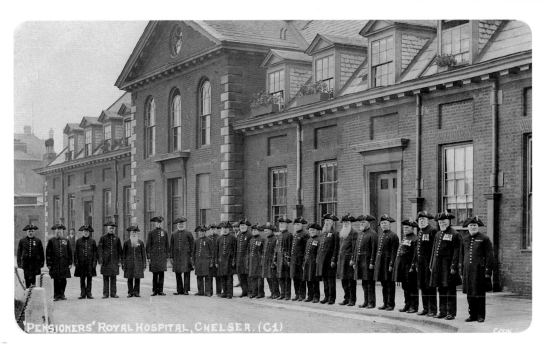

The Royal Hospital, Chelsea, *c.* 1906

The foundation stone for this renowned hospital and ranges of living quarters for veteran soldiers was laid by Charles II in 1682. Most of the grand and spacious buildings within the hospital complex were designed by Sir Christopher Wren, with later alterations by Robert Adam and Sir John Soane. The view here is of the North East Court, where benches provide a pleasant spot for Pensioners to sit out in the sunshine. The Royal Hospital is distinguished by its Pensioners in their scarlet coats, a uniform that, like the surroundings, has changed little through the centuries.

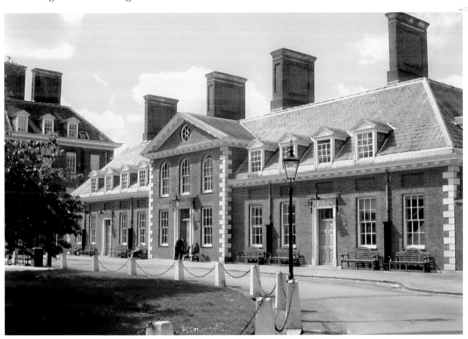

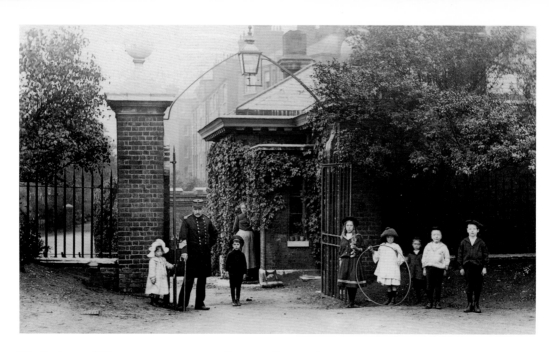

The Lodge and Western Entrance, Royal Hospital, *c.* 1906
Chelsea Pensioners make a much loved and familiar part of the Chelsea scene and are often seen out and about. A far less mobile 'Pensioner' is the model of one that permanently adorns the bench just inside the Western Entrance, seen here. The earlier image has captured a Pensioner with a line-up of local children.

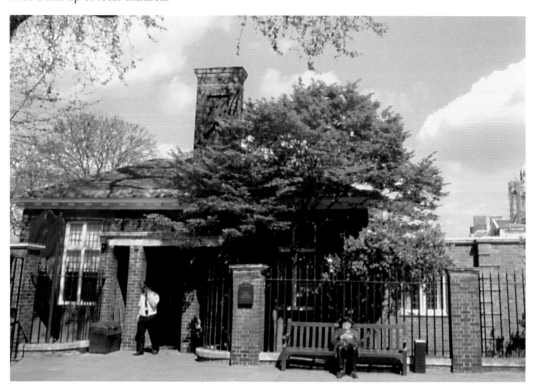

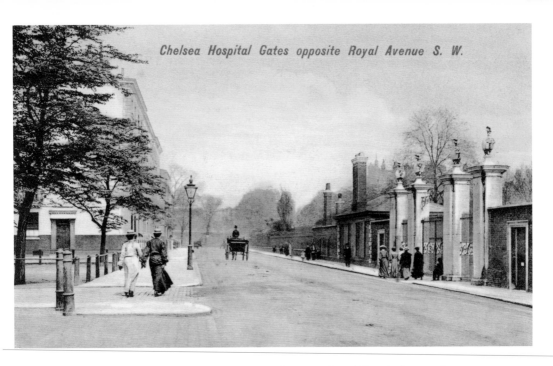

Chelsea Hospital Gates opposite Royal Avenue S. W.

St Leonard's Terrace and Entrance to Burton's Court, Royal Hospital, *c.* 1906
While some parts of Chelsea have changed out of all recognition, others remain reassuringly well preserved, as seen here where houses from the 1700s and later face Burton's Court, an open space in front of the Royal Hospital. The older houses of St Leonard's Terrace are behind the cameraman, including one that was the home of Bram Stoker, the creator of *Dracula*, from 1896–1906.

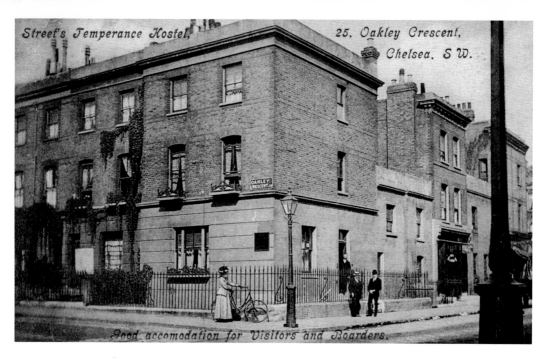

Oakley Crescent and (Chelsea) Manor Street, *c.* 1908

A century ago, much of the area between King's Road and the river had a mixture of Victorian streets with terraced housing, small workshops and the odd block of mansion flats for the well-to-do. Crescents were rare in Chelsea, and indeed this one had the right-angled corners more usually seen in London squares. Oakley Crescent was built around 1850; with Chelsea's increasing trendiness, this old hostel evolved into a smart address.

Dr Phené's House, Upper Cheyne Row by Oakley Street, c. 1905

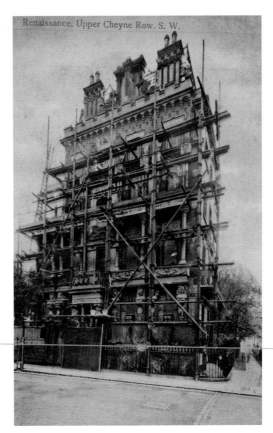

As may be expected in an area that has long attracted talented artists, writers, actors and other luminaries, Chelsea has also gathered a colourful array of eccentrics. Notable among them was antiquarian Dr John Phené, who created an extraordinary house of two halves – all staid Victoriana on the Oakley Street side, but facing Upper Cheyne Row there was a riot of exotic embellishment including curious carvings, busts, candy-twist columns and much more besides. The work began in 1903, lasting until 1905, when what had become known as 'The Mystery House' was revealed to an astonished Chelsea. Such was the interest, this postcard was published to celebrate the emerging wonder, still with part of the builders' wooden scaffolding in place. In true eccentric style, Dr Phené never lived in his creation, and, in 1917, it was demolished with a more traditional property taking its place. Dr Phené has not been forgotten, however – 'Phené Street' preserves the name of a true Chelsea character.

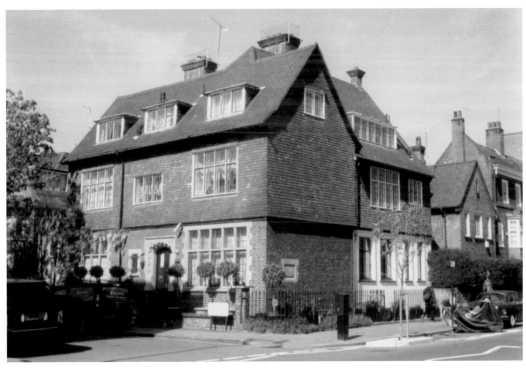

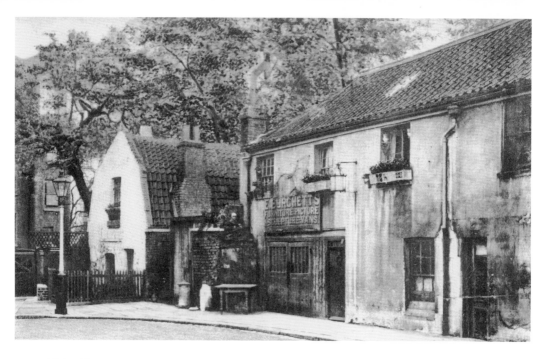

Glebe Place, *c.* 1905

This street is made up of two parts, a spacious road of Victorian houses and artists' studios, while its shorter bottom section contains rare and picturesque reminders of a rural past. The aged cottages and stables of the earlier view have been much altered and we see them here when furniture remover Edward Burchett was in residence. The old buildings display their pantiled roofs, a once common local style that has now all but vanished. Much of Glebe Place was laid out *c.* 1870 on the former kitchen gardens of Chelsea Rectory.

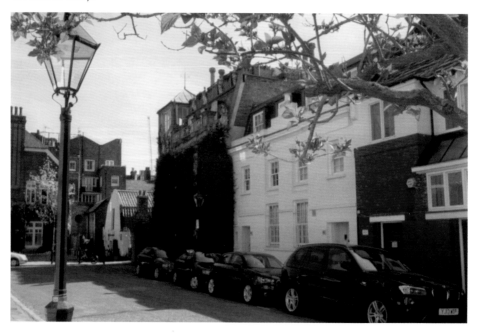

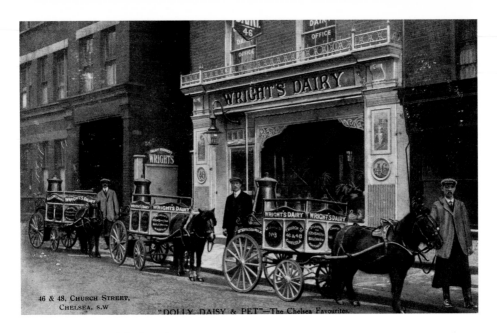

Wright's Dairy, (Old) Church Street, *c.* 1910

The dairy was established in 1796 after which it opened further branches in Kensington, Mayfair, and Belgravia. A famous client was local celebrity Thomas Carlyle and a pair of goats was kept to supply the Carlyle household with milk. The view shows the carts and churns for local deliveries when the milk was dispensed directly into the householders' own receptacle – bottled milk had yet to appear. The ponies that drew the carts were popular local characters and a tradition of horse-drawn carts was maintained after Wright's was taken over by United Daries. A cow's head can still be spotted high on the wall of what is now known as the Old Dairy in its modern residential role.

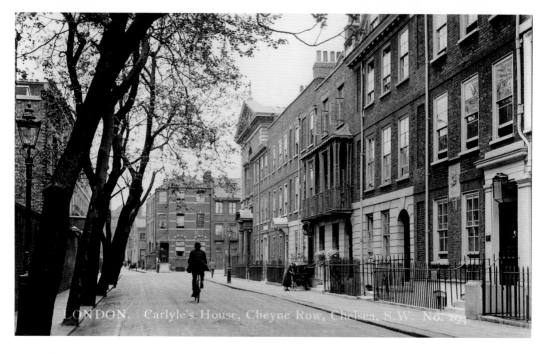

Cheyne Row, *c.* 1920

Prominent among the writers who found Chelsea an inspirational place to live was Thomas Carlyle, 'the Sage of Chelsea', who set up home in this mellow brick terrace that ran down to the pre-embanked river. The historic houses here date from 1708, with Carlyle in residence from 1834–81; his house is on the right of the image. In 1895, the house became a museum devoted to the great man and this can still be visited. The Church of Our Most Holy Redeemer (1905) with its grand pediment can be spotted at the end of the terrace.

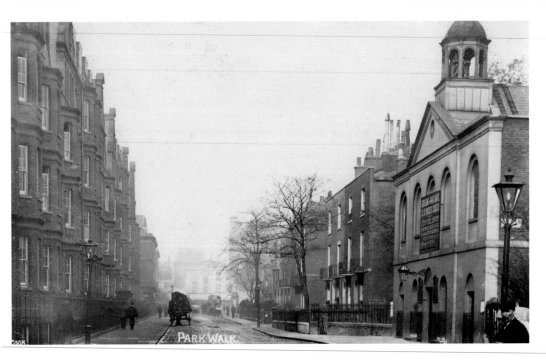

Park Walk and Emmanuel Church (Park Chapel), *c.* **1905**

The small chapel on the Camera Square (Chelsea Park Gardens) corner was built in 1718, but its long life was coming to end and a board announcing that a new parish church was to be built here was already in place. The new St Andrew's church by Sir Arthur Blomfield was consecrated by the Bishop of London in 1913.

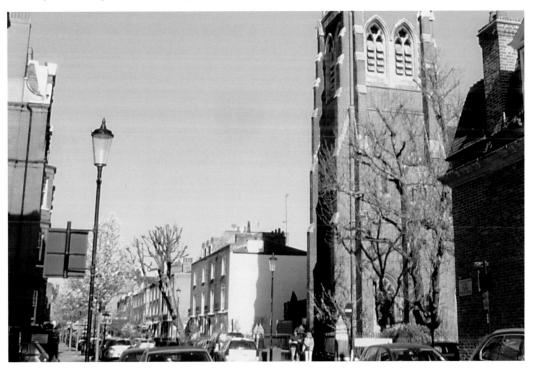

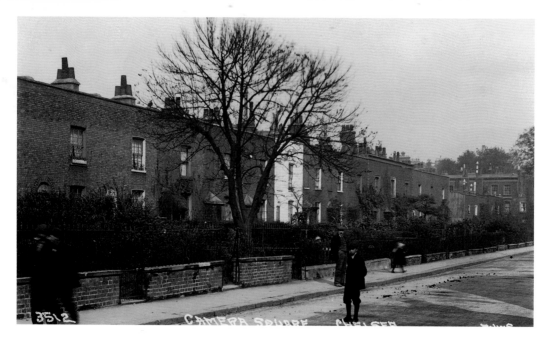

Camera Square (Chelsea Park Gardens), *c.* 1912

With its modest cottage-like houses and extraordinarily lengthy front gardens, this was a London square with a difference. Camera Square was laid out around 1821 and even in its twentieth century later life, the atmosphere remained that of a rural village rather than one of London's Metropolitan Boroughs. It had all changed by the mid-1920s, however, when Chelsea Park Gardens with its picturesque gables and mansard roofs took its place; the leafy aspects of old were fortunately retained.

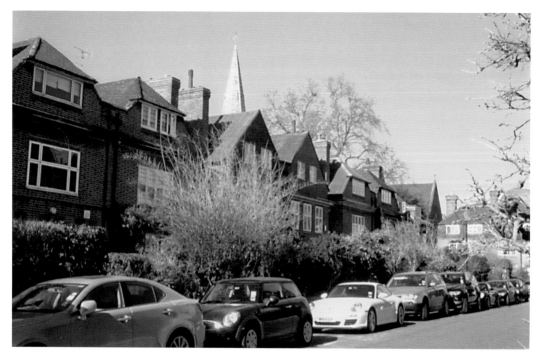

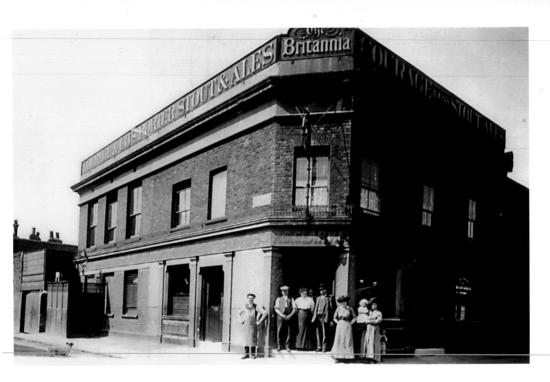

The Britannia, Beaufort Street by Little Camera Street (Chelsea Park Gardens), *c.* 1906
A long-lost pub whose aspect was far removed from the affluent environment of modern Beaufort Street – note the cast-iron urinal with its own gas lamp in Little Camera Street (*left*). Old shops in Beaufort Street (*right*) have also long departed, as have the commercial premises on the left where builders G & E Kent traded. The houses subsequently built here were in the picturesque style of the rest of Chelsea Park Gardens (*image courtesy of Maurice Friedman*).

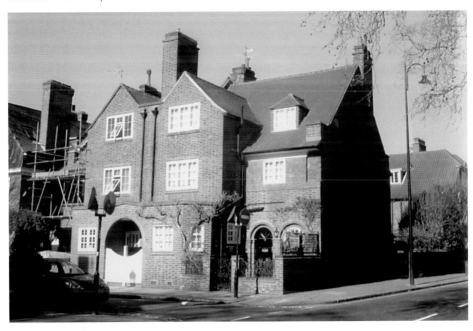

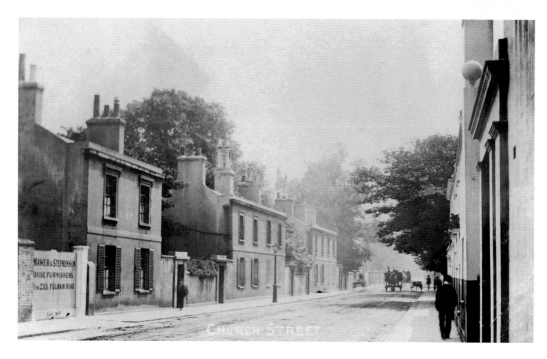

Church Street, *c.* 1906

Church Street, later called Old Church Street, comes in two halves. The southern section leads to the old riverside village and was steeped in antiquity, while the part to the north of King's Road developed later and was more in the style of a Regency suburb, as typified by this row of stucco-fronted villas. Their sites took on a dramatic new look in the mid-1930s with the construction of a pair of widely admired houses that embraced the emerging concept of continental modernism. One of the houses included designs by Walter Gropius, the founder of the Bauhaus school of architecture.

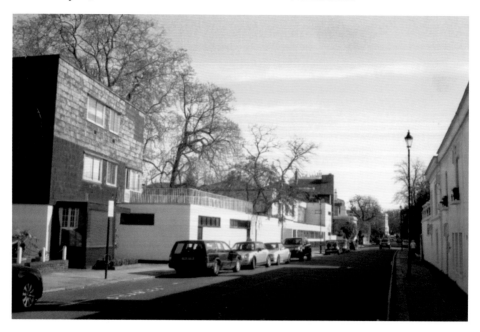

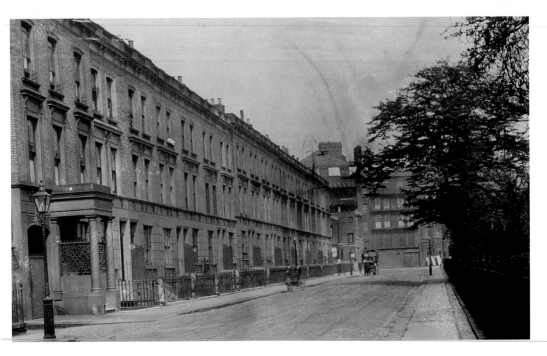

Trafalgar Square, West Side (Chelsea Square), *c.* 1906
An air of gloom was apparent in this square of plain houses, which were descending into faded gentility and eventual demolition by the 1930s. In their place came a bright new development of neo-Georgian town houses with a new name, Chelsea Square. The old name was dropped to avoid confusion with other Trafalgar Squares in London.

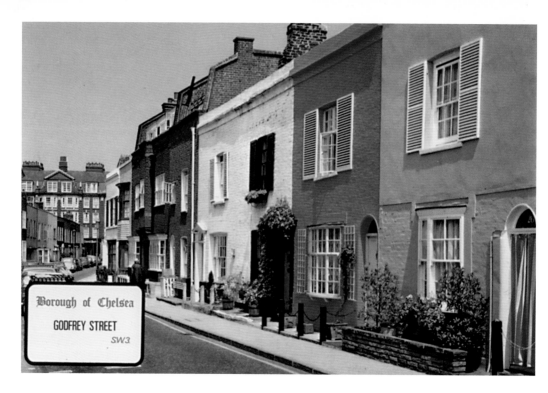

Godfrey Street from Burnsall Street, 1960s

This street represents the classic post-war regeneration of those modest early properties that survived wartime air raids and other clearances. These streets became trendy and gentrification transformed formerly drab neighbourhoods into colourful enclaves of desirable homes. The process continues with the more restrained hues of the present day, and a furthering of the fashion for loft conversions and new basements.

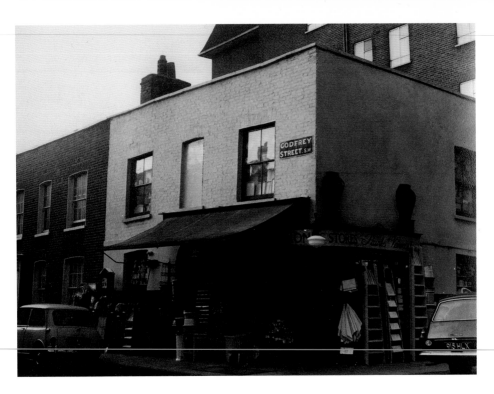

Simmond's Domestic Stores, Godfrey Street by Cale Street, 1964
Despite the tide of gentrification spreading through Chelsea's back streets, some long-established businesses were continuing to thrive, including this useful family-run hardware shop. It was a survivor from Victorian times when oilman Albert Simmonds was at the helm. Eventual closure was followed by partial rebuilding, but part of the shop's legacy still adorns the wall on the Cale Street side.

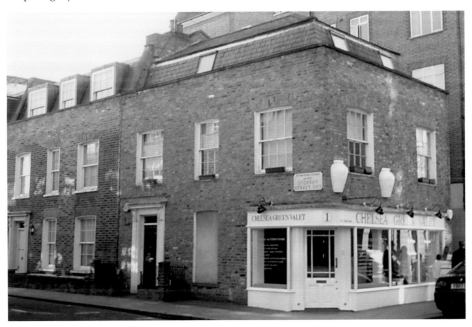

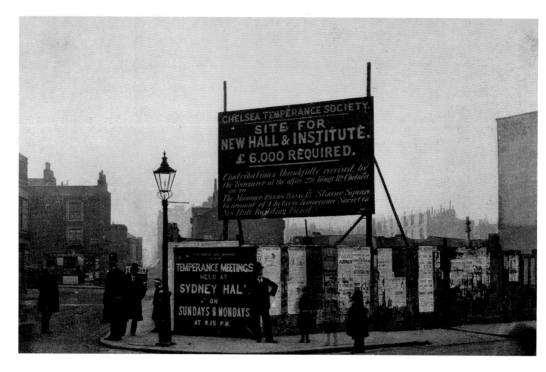

Pond Place and Leader Street (Ixworth Place) from Cale Street, c. 1907
Old slums had been cleared and a large site awaited a new hall for Chelsea Temperance Society
and a new estate of model dwellings for the Samuel Lewis Trust. Fundraising for the Chelsea
Temperance Society was ongoing, with a further £6,000 still needed but by 1908 a new 'Sydney
Hall' arose further along Pond Place (*left*). The new residential blocks of the Samuel Lewis Trust
arose in 1915 and gave residents of northern Chelsea a considerably improved standard of living.

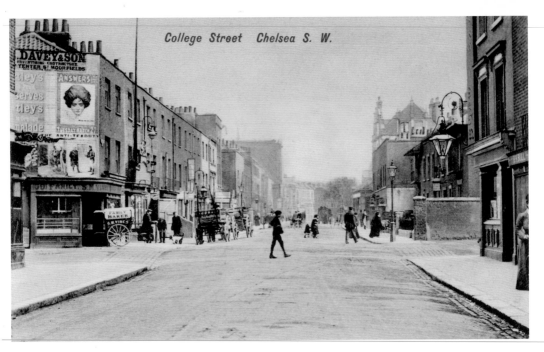

College Street Chelsea S. W.

College Street from Leader Street (Ixworth Place), *c.* 1906
When pictured here, College Street was about to lose its name (a change to Elystan Street was proposed), but its mixture of decaying commercial and residential properties still had a few more years of life. By the late 1920s, the whole area had been cleared to make way for a new world of flats and, at its further end, a row of shops serving a new estate of 'model dwellings'. Samuel Vine's bakery on the Leader Street corner was a typical enterprise in old College Street (*left*).

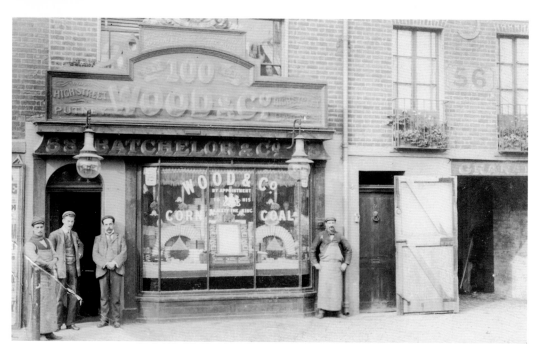

Wood & Co., Nos 56–58 College (Elystan) Street, c. 1905
Edwardian College Street was a bustling thoroughfare full of craftmens' workshops and small shops typical of many such streets in impoverished areas of London. Wood & Co. were one of the more prominent businesses occupying adjoining premises, including a granary (*right*); the firm were coal and corn merchants. A royal warrant was proudly displayed.

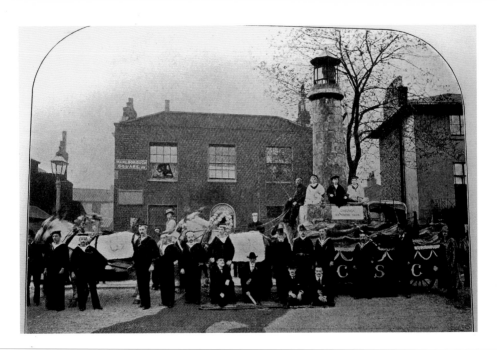

Marlborough Square Between Cale Street and Leader Street (Ixworth Place), 1900
This was more a triangle than a square, with a central open space overlooked on three sides by a mixture of houses and commercial premises. This old square was wiped from the map in 1912 by the building of Sutton Model Dwellings, a large estate of residential blocks. The photograph was taken during a carnival held in October 1900 in aid of the *Daily Telegraph* fund for the widows and orphans of those of Her Majesty's Forces who fell in the Boer War. Seen here is the Lighthouse Tableau, a contribution from the Chelsea Swimming Club; it featured scenic effects and demonstrations of life saving techniques.

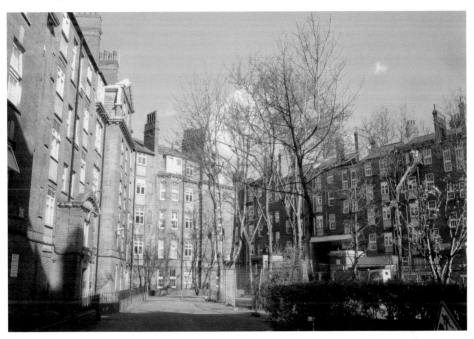

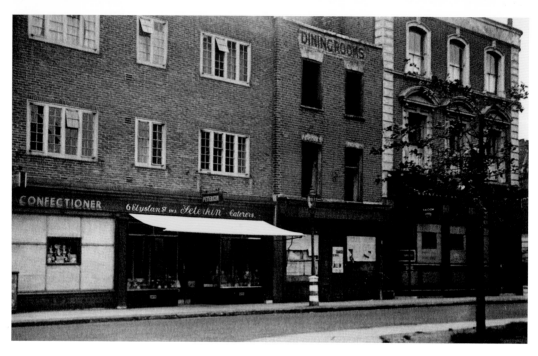

Elystan Street from Cale Street, Chelsea Common, 1940s
The 1940s brought bomb damage followed by the drabness of post-war austerity, as seen here with abandoned properties and restricted shop window displays – a legacy of the blackout. The location here was part of the former Chelsea Common, some 37 acres that were enclosed by the landowning Cadogan family who built neighbourhoods of small houses here early in the 1800s.

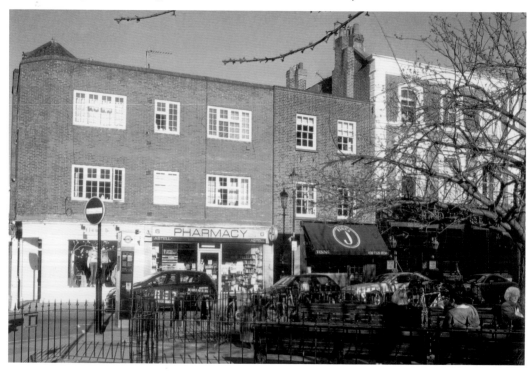

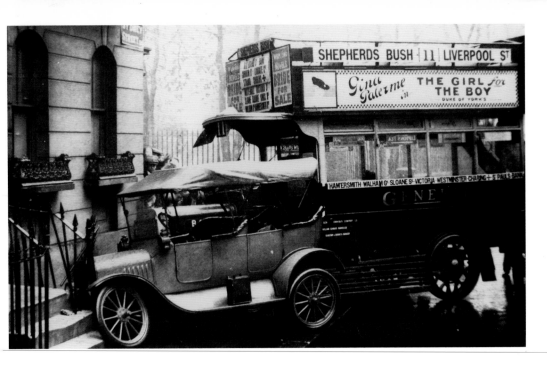

Road Accident, Sydney Street by Cale Street, 1920s

There was a nasty shock for the basement dwellers here as a crashing motorist and a No. 11 bus invaded their space. The bus was owned by the London General Omnibus Company; bus route 11 is more usually seen in King's Road. This chaotic scene was overlooked by the more serene presence of St Luke's church, which was built from 1820–24 for the then expanding population of Chelsea, and to take some of the congregation from tiny Chelsea Old Church.

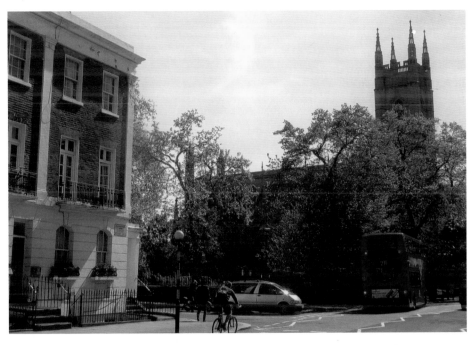

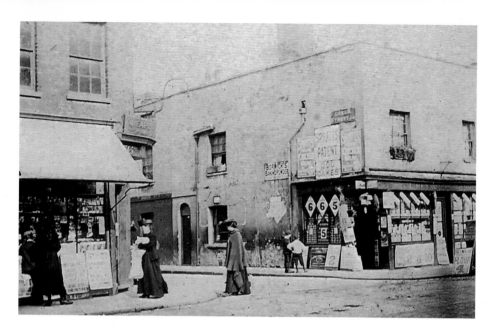

Marlborough Road (Draycott Avenue) by Green Street (Mossop Street), *c.* 1904
Pockets of slum properties still existed in early twentieth-century Chelsea, as seen here, where basic shops struggled in a very deprived area. Newsagents Toler Bros are seen on the Green Street corner (*left*) with Charles Reynolds the corn dealers standing opposite. When this area still had a rural profile, Green Street was called Green Lettuce Lane, but the street was renamed Mossop Street in 1939, and Marlborough Road was known as Draycott Avenue after 1906. The squalor of old has been long forgotten here and a smart new telephone exchange arose. New commercial property has replaced the old Reynold's shop (*Image courtesy of Maurice Friedman*).

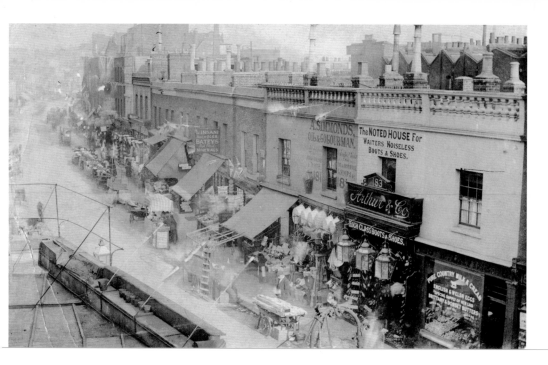

Marlborough Road (Draycott Avenue), *c.* **1905**
Here is a classic example of how a street in a deprived part of Chelsea has been transformed in a century into one of smart shops and fashionable restaurants. Old Marlborough Road was lined by tiny shops, and a bustling street market ran far along the road. Among the shops on the right were William Davies Dairy Arthur & Co., 'The noted house for waiters' noiseless boots and shoes', alongside Albert Simmonds, oil and colour man. Even in this lowly area, rooftop balustrades made an elegant touch but all is modernity now.

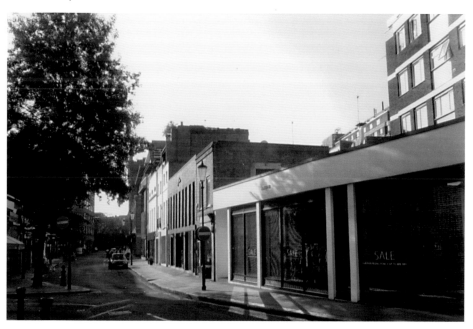

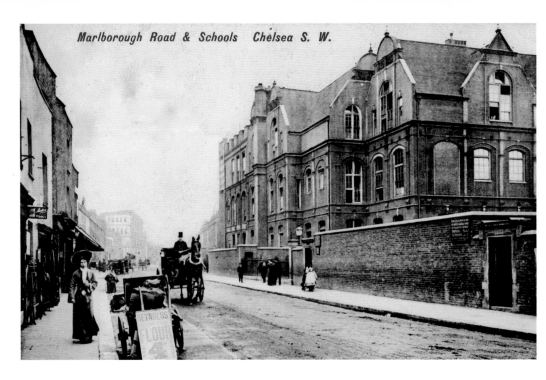

Marlborough Road & Schools Chelsea S. W.

Marlborough Road School, Draycott Avenue, c. 1907
The school was built in 1878 for the School Board for London, an organisation that set out to provide regular education in what were then poor parts of London. Many of these handsome former Board Schools still stand, including Marlborough Road, although its neighbourhood was entirely rebuilt in the twentieth century. The ragged row of shops on the left ran from Green (Mossop) Street and beyond Denyer Street to long-lost Little Orford Street (now Rosemoor Street).

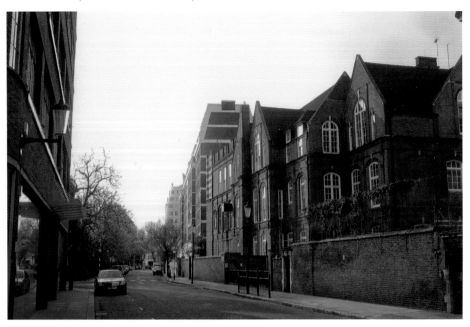

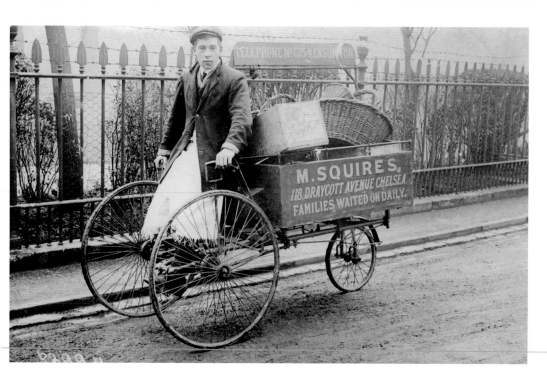

Martin Squires, Fruiterer, Draycott Avenue and Walton Street, c. 1910 and c. 1907
A tricycle for local deliveries and a prominent corner shop for a thriving business from a century ago. Walton Street is a rarity, its small but historic properties of a type that have been swept away from many areas of London, but here they have been preserved and turned into upmarket shops, galleries and restaurants.

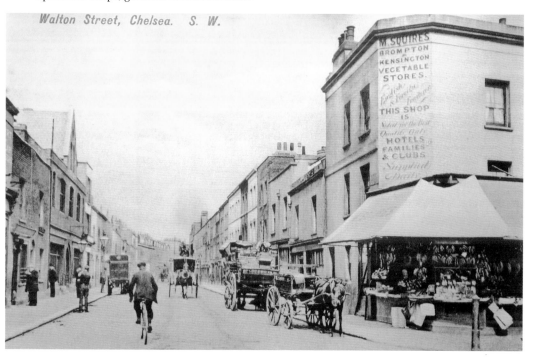

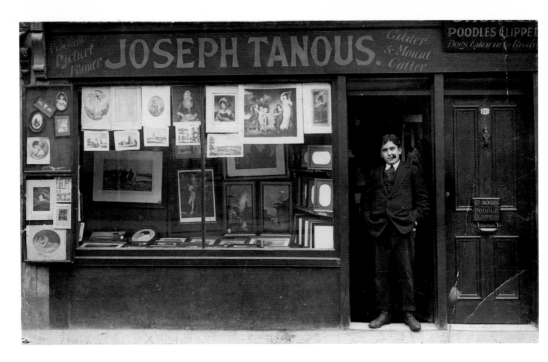

Joseph Tanous, No. 103 Walton Street, *c.* 1911
Art, antiques and specialist collectors' shops have long found a home in Chelsea, as seen here where Joseph Tanous traded as a picture framer and dealer. Further Tanous shops graced the Chelsea scene in later years. Next door, Mrs Elizabeth Jackson, poodle clipper, provided an assortment of services for the Edwardian pooch and there were boarding kennels. The change of use to a modern restaurant is typical for Walton Street.

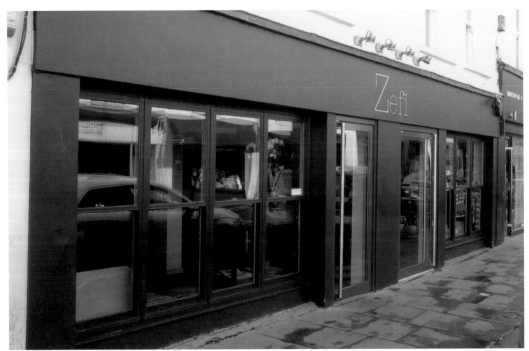

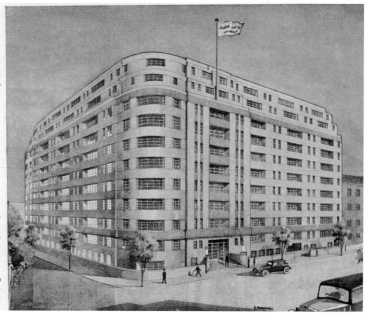

Sloane Avenue Mansions, Sloane Avenue, *c.* 1934

One of Chelsea's most ambitious improvement schemes during the inter-war years involved the clearance of a large area of worn-out properties between King's Road and Fulham Road. The result was Sloane Avenue, a broad tree-lined thoroughfare along the line of the former Keppel Street. Although the take-up of building sites along the new road was slow, when building did begin, it took the form of upmarket apartment blocks that reflected a growing fashion for this type of living in town. We may look in envy at the asking prices for living here, but in the 1930s these costs were high and unaffordable for many.

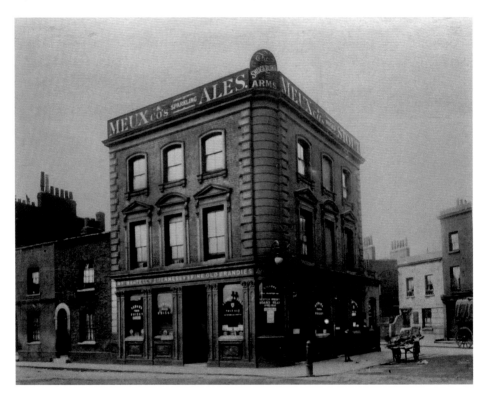

The Shuckburgh Arms, Denyer Street, *c.* 1910

Chelsea was one of those areas of London where wealth and poverty existed in close proximity and could be seen in the contrasting fortunes of neighbouring streets. This classic Victorian pub was located on such a boundary, with down-at-heel Denyer Street on the left and prosperous Milner Street just off-camera, to the right. Part of Green Street (Mossop Street) is seen behind the costermonger's barrow.

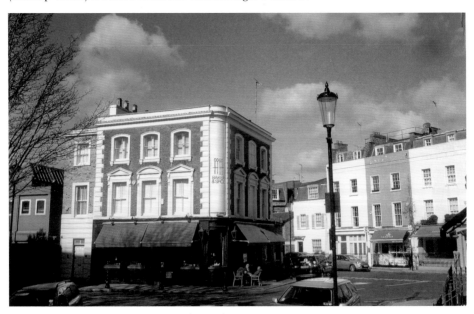

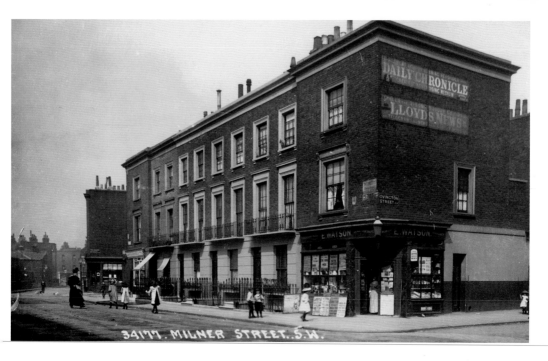

Milner Street by Ovington Street, c. 1905

In this spacious street there were good examples of terraced rows of town houses of a superior kind, complete with cellars for the convenient storage of coal. This was delivered through circular openings in the pavement. Further amenities included a corner shop at both ends of the terrace – Mrs Ellen Watson's newspaper and stationery shop was matched by Albert Ashby, the window-blind maker at the further end by Hasker Street. Attic conversions have given new looks to the rooflines.

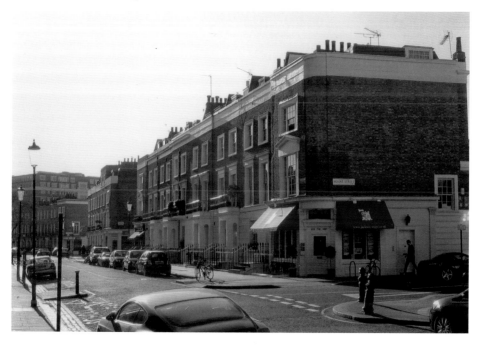

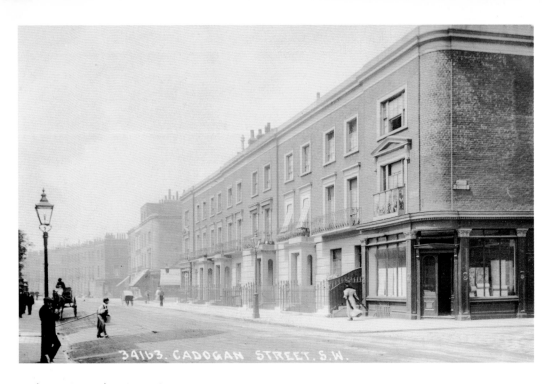

Cadogan Street by Moore Street, c. 1905

These early nineteenth-century terraces repeat the arrangement seen in Milner Street with a corner shop at each end. The Cadogan names hereabouts come from the landowning Cadogan family, who built up the area.

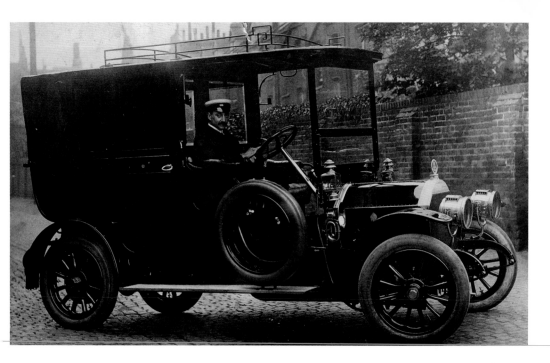

Limousine and Chauffeur, Lennox Gardens Mews, *c.* 1912

Chelsea has fewer mews streets than neighbouring Kensington, but a number of these picturesque byways can be found in the more traditionally aristocratic areas of the borough. These streets were built as stables and coach houses, but with the advent of the motoring age they were readily adapted as garages and motor workshops, with accommodation for the chauffeur upstairs. This in turn led to a third phase of life, as many mews properties were lavishly converted into highly desirable inner city homes as seen here in Lennox Gardens Mews.

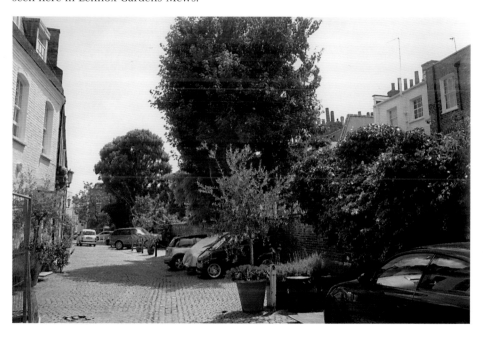

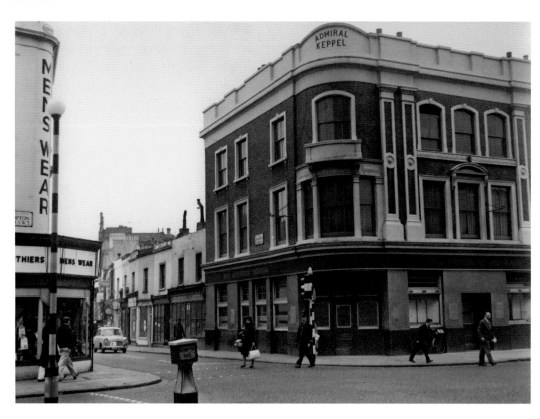

The Admiral Keppel, Fulham Road by Draycott Avenue, 1962
An old house of refreshment seen here in its final days, boarded up and ready for the
wrecking crew. This was once a country inn and tearoom on the rural road to Fulham
before it was rebuilt in typical Victorian style in 1856. Today the new shops display the
trendiness of modern shopping in Chelsea with smart flats in the upper parts.

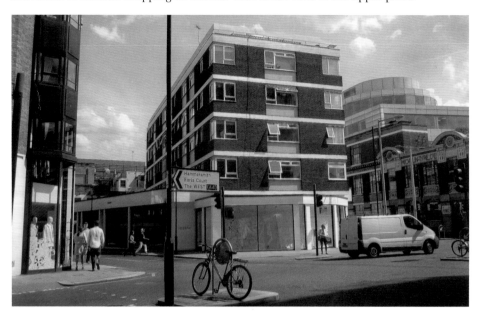

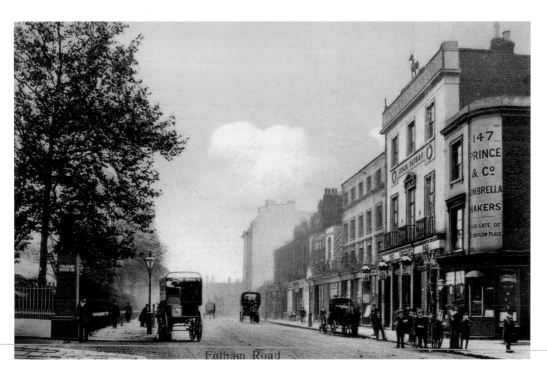

Fulham Road Opposite Pelham Crescent, *c. 1907*

The old neighbourhood has been entirely lost, mostly from the 1930s when the Stag pub, the adjacent shops and the hinterland behind were replaced by the new apartments of Thurloe and Pelham Courts and accompanying shops. Among the casualties behind the old shops were Onslow Model Dwellings, a mid-Victorian social housing scheme.

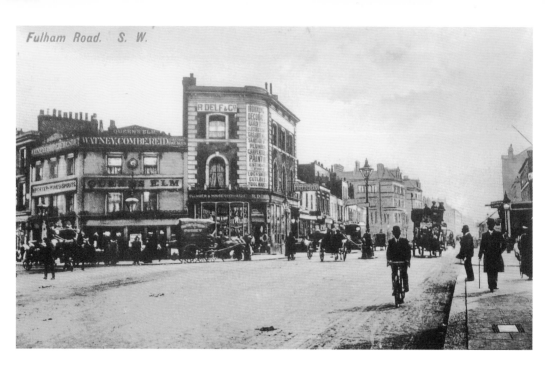

Fulham Road. S. W.

The Queen's Elm, Fulham Road by (Old) Church Street, *c.* 1906
This was another of the old houses that refreshed the traveller on the road to Fulham. The pub and adjoining shops were given a new look in the 1930s, but further shops took over the main premises following the closure of the pub.

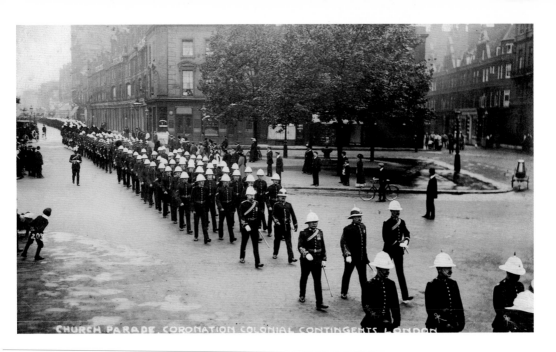

CHURCH PARADE, CORONATION COLONIAL CONTINGENTS, LONDON

Sloane Square, 1911

The name of Chelsea's busiest square honours physician and naturalist Sir Hans Sloane (1660–1753), who lived in Chelsea and whose collection of artifacts formed the nucleus of the British Museum's collection. Sloane Square first appeared on the map in the late 1700s as the area was being built up, its roadways adopting a variety of layouts before the present circulatory system was introduced. In this view, a road cuts across the central area (*right*) and also pictures a military church parade, part of the colonial contingents who were camped at the Duke of York's Headquarters at the time of King George V's Coronation.

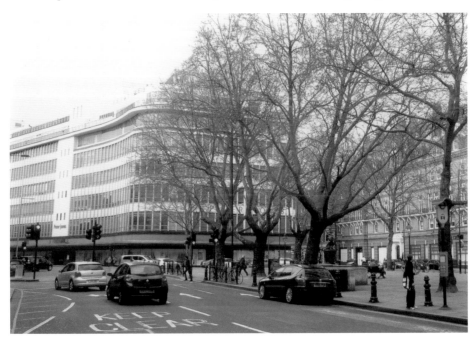

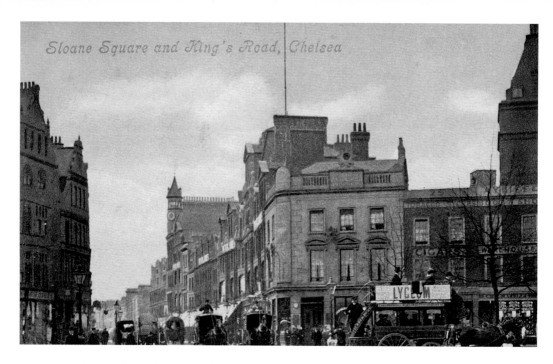

Peter Jones, Sloane Square and King's Road, *c.* 1908

Welshman Peter Jones came to London to seek his fortune; the measure of his success may be judged by the grand store that arose bearing his name. Nos 4–6 King's Road were acquired in 1877, with expansion into neighbouring shops following until there was an opulent emporium that ran through to Symon's Street. In this Edwardian view, the small shops facing Sloane Square including the Star & Garter pub had yet to be acquired, but from 1932–36, the store's great rebuilding in a striking modernist style took in much of a large island site running along to Cadogan Gardens.

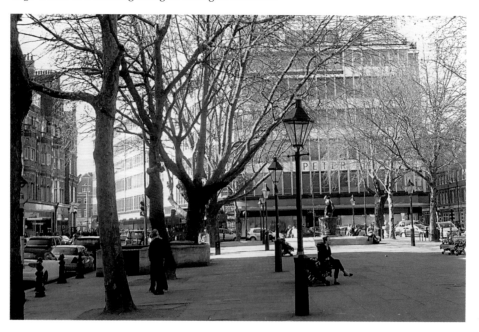

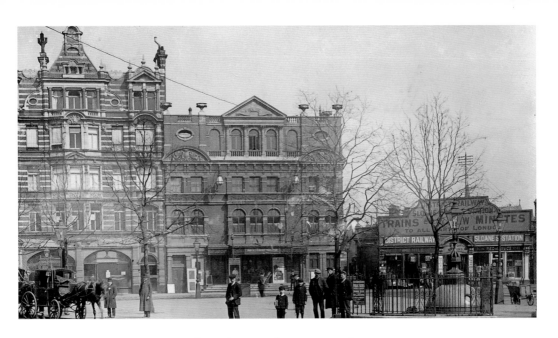

Sloane Square East Side and Royal Court Theatre, *c.* 1906

No trace remains of the small houses and shops that made up the first phase of building in Sloane Square, but the grandiose rebuildings of the late Victorian and Edwardian eras still stand. These include the Royal Court Theatre by W. R. Crewe, which opened in 1888. The theatre became noted for its first public performance of plays by George Bernard Shaw, and later by John Osborne. The theatre was used as a cinema from 1935 until war damage closed it; it reopened in 1952 after reconstruction. The District Railway's Sloane Square station is on the right.

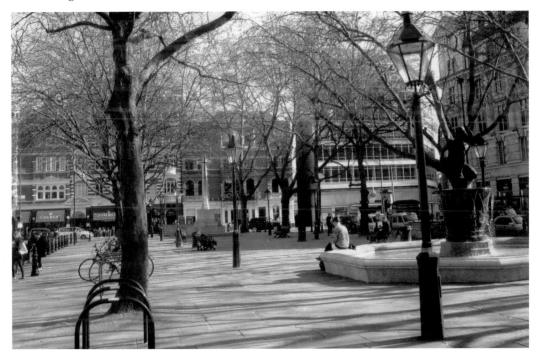

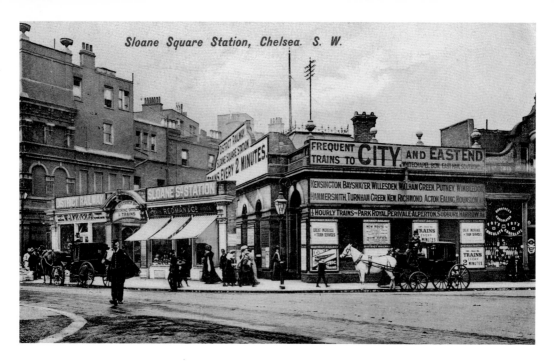

Sloane Square Station, Chelsea. S. W.

Sloane Square Station, *c.* 1906

One of two underground stations in Chelsea, Sloane Square opened in 1868 on an extension of the District Railway from South Kensington. When the station was being built, excavations encountered an obstacle in the form of the subterranean River Westbourne, which was originally a surface feature; its waters now run in a pipe above the platforms. War damage and a series of rebuildings have given the station a new look, but at platform level some surviving Victorian brickwork dates from the days when steam locomotives hauled the trains.

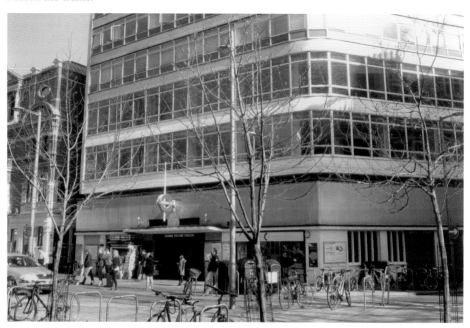

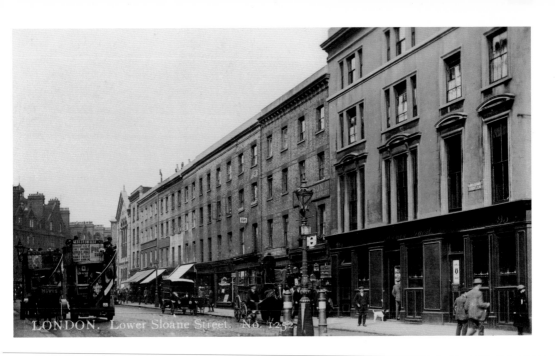

Lower Sloane Street from Pimlico Road, *c*. 1920

This shopping terrace was once part of an earlier road called White Lion Street; it became Lower Sloane Street in the 1880s. Only three properties have survived from the originals, which were becoming run down and drab in the 1920s. A lost landmark at the far end was Chelsea Baptist Chapel (1814), while on the right, the Coach & Horses pub has also departed. The shop next to the pub was that of Thomas Dawson, bird dealer – the keeping of caged birds was then a popular pastime.

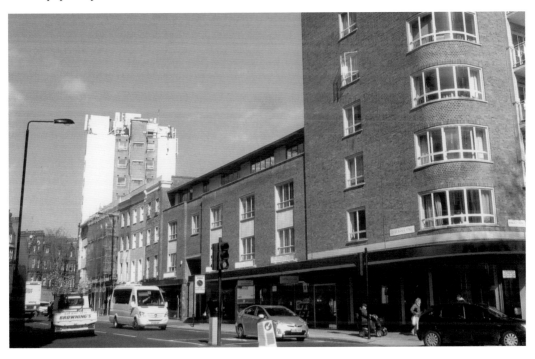

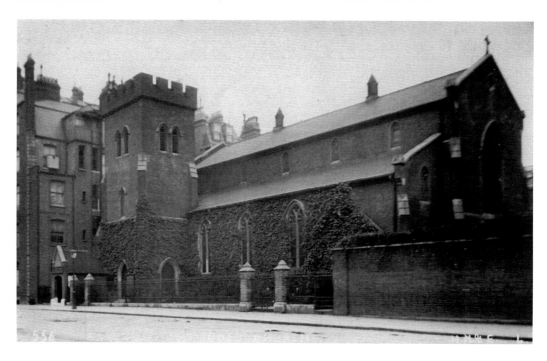

St Jude's Church, Turk's Row, off Lower Sloane Street, *c.* 1912
This modest brick-built church was by George Basevi and was erected from 1833/34. It was distinguished by an impressively battlemented tower. The church closed in 1932 and was demolished in 1934, with residential York House taking the site. The street name 'Turk's Row' dates from around 1746 and is thought to have derived from a coffee house sign.

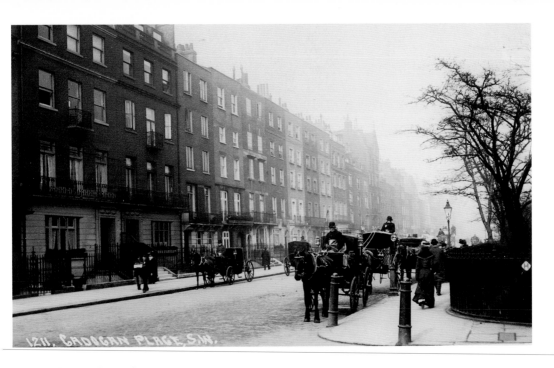

Cadogan Place, Sloane Street, *c.* 1904

Classic elements of Edwardian London are seen here with gas lamps and a cab rank made up of hansoms and growlers (four-wheeled cabs). Lofty town houses have long characterised Sloane Street and part of that legacy remains today alongside smart apartment blocks. The cast-iron bollards are dated '1819' and proclaim that this is 'Hans Town', then a new quarter for London centred on Sloane Street.

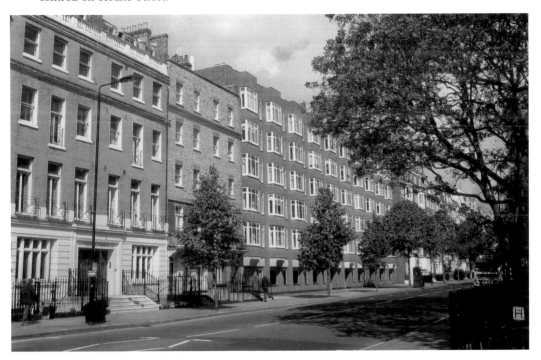

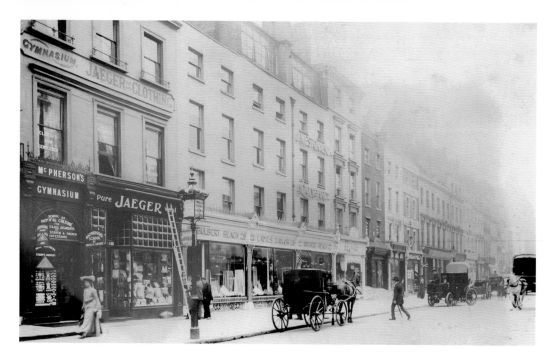

Sloane Street near Hans Crescent, c. 1904

The street is known worldwide for its fashionable emporia, drawn from the worlds of art, antiques and high fashion. The area was equally aristocratic in Edwardian days, with elegant costumiers, milliners and hair dressing salons. Most of the original properties have been replaced, but a surviving handful remind us of times gone by. On view here are McPherson's Gymnasium with 'classes for ladies and children' and Dr Jaeger's wool shop, followed by Hulbert Beach, ladies' tailor, in a triple-fronted shop.

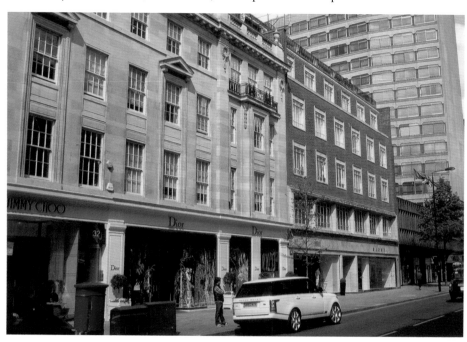

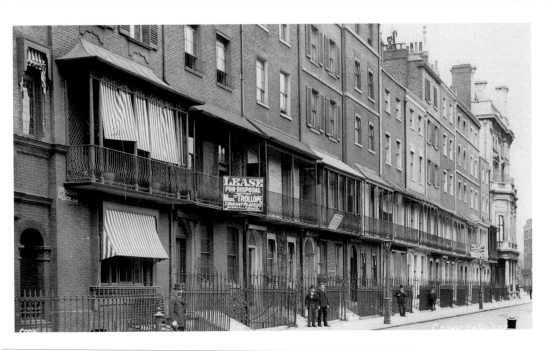

Cadogan Place from Sloane Street, c. 1906

This eighteenth-century terrace was replaced in spectacular fashion in 1961 when the eighteen-storey Carlton Tower Hotel rose high above the low-rise townscape. This was the first of the lofty post-war hotels to arrive in this part of Chelsea. Just visible at the end of the old terrace was Chelsea House, the Cadogan family's London mansion; it was replaced in 1935 by a residential block also called Chelsea House.

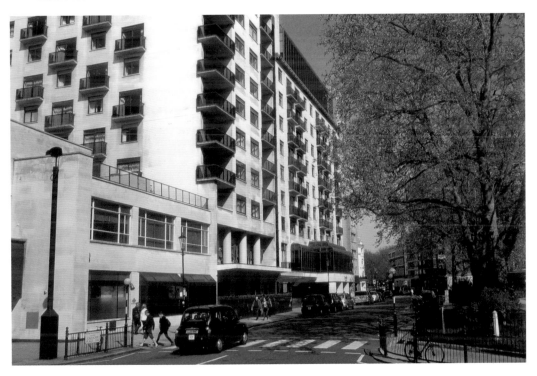

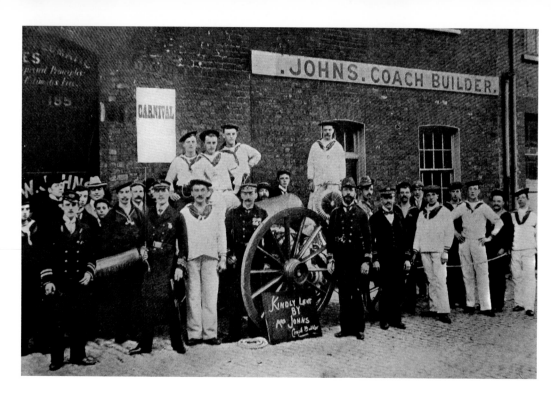

Mrs Ellen Johns, Coach Builder, No. 187 Pavilion Road, 1900
'The Naval Gun' was another participant in the fundraising carnival precession of 1900.
There were 124 individual floats, tableaux and bands on a processional route that took
in Chelsea, Kensington, Knightsbridge and Belgravia. The carriage here had been lent by
Mr Johns who traded in Pavilion Road, a mews and service street for Sloane Street,
Cadogan Square and Gardens.

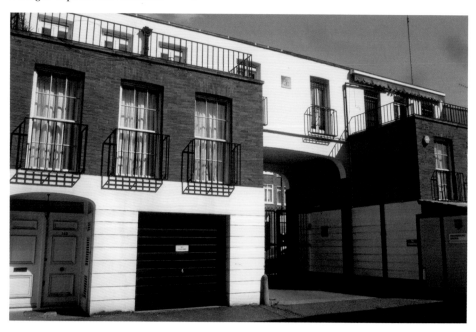

Snoad's London & County Stores, No. 440 King's Road by Limerston Street, c. 1905

A contrast with the lofty opulence of Hans Town was offered by western Chelsea, where King's Road runs towards the Fulham boundary at Stanley Bridge. To the north are spacious streets of low-rise terraces, but to the south there was formerly a densely packed grid of mid-Victorian streets, which were run down and eventually replaced by the World's End Estate. Plentiful shops along King's Road served these diverse neighbourhoods and among them were the London & County Stores. Here the working day began with the setting up of the outdoor display of stock, a lengthy process given the sheer volume of household essentials involved.

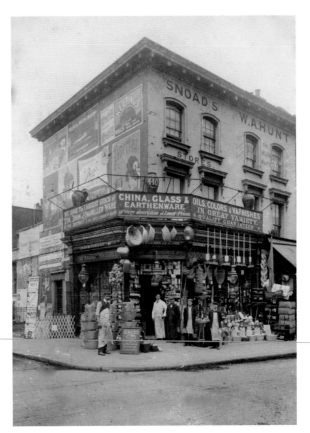

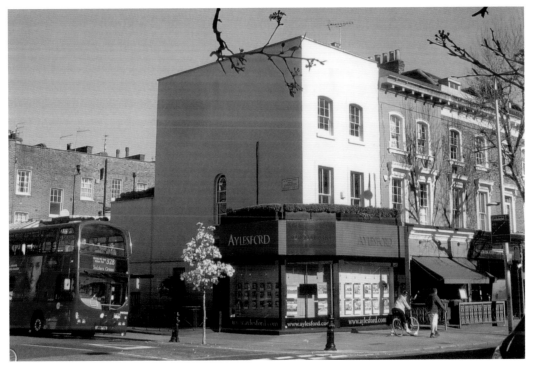

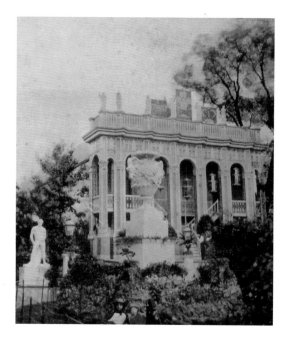 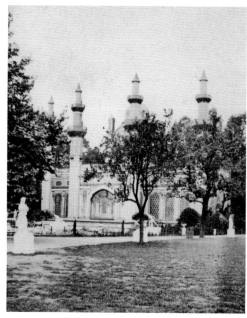

Cremorne Gardens, *c.* 1870s

Cremorne Gardens began as a sports stadium in 1832, but it was not until the 1840s that it evolved into a popular and spectacular pleasure resort with music, theatre and balloon ascents, alongside quiet corners with gardens and grottoes. Victorian Londoners thronged the resort, but it was controversially raucous and it closed amid some notoriety around 1877. A modern garden has taken a little of the old site.

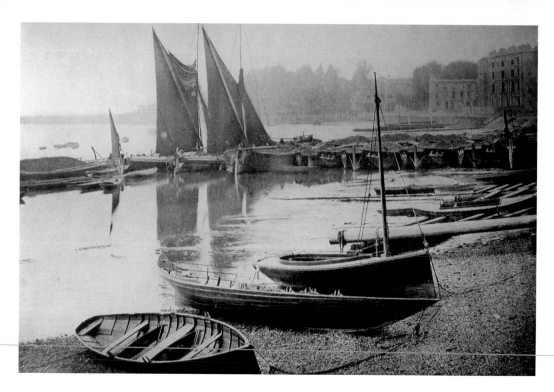

Lindsey Wharf and Cremorne Road (Cheyne Walk) from Battersea Bridge, *c.* 1865
Mixed shipping, much of it commercial, was drawn up on the foreshore at low tide.
Distant trees mark Cremorne and its pleasure gardens, while at Cremorne Road (Cheyne
Walk) builders were beginning work on the new streets, including Seaton, Luna, and
Blantyre Streets – the future site of the World's End Estate. The great riverside landmark
of Lots Road Power Station lay far into the future.

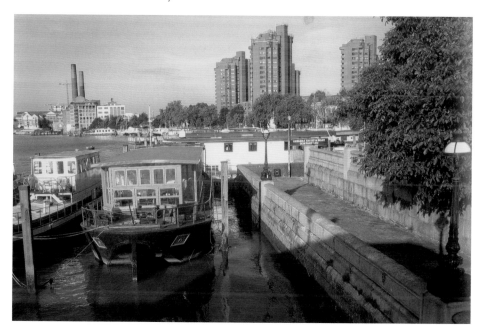

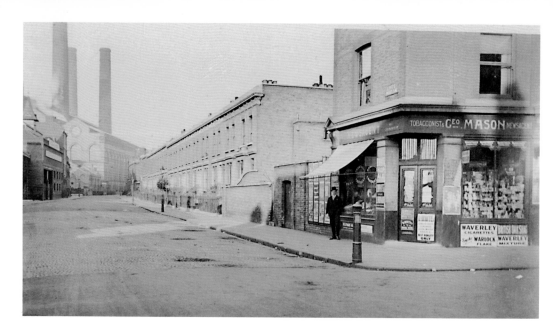

Lots Road and Power Station, *c.* 1906

Built on part of the Cremorne Gardens site, the power station began operating in 1905, supplying electricity to the underground railways. The downside, however, was air pollution, which blighted the populous neighbourhoods that lay in its shadow. The power station lost two of its four chimneys in 1963 when its fuel was changed from coal to oil. The station was finally decommissioned in 2001. The surrounding streets were then able to regenerate and Lots Road became a desirable place to live. Edwardian Lots Road is seen when George Mason ran the newsagents and tobacconist's shop on the Cremorne Road corner.

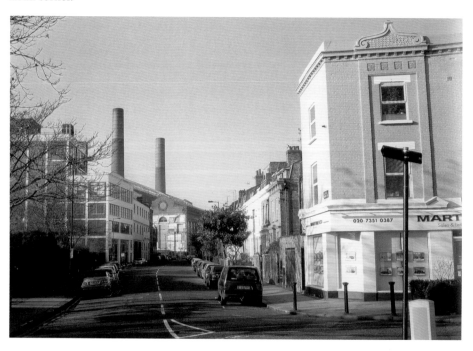

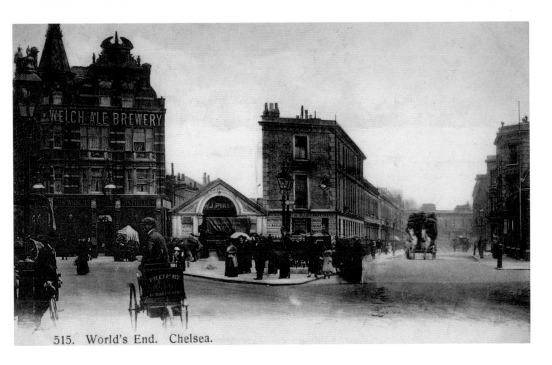

515. World's End. Chelsea.

The World's End, *c.* 1906

The view looks across King's Road to a lost world of overcrowded Victorian streets based around Blantyre and Seaton Streets. This was all swept away with the building from 1967 of the World's End housing estate. On the left is the World's End pub, an 1897 rebuilding of an earlier tavern and tea gardens. Its low-rise neighbour housed W. J. Pike, a firm of removal contractors, established in 1840. The building went on to serve a variety of occupants including the Cremorne Cinema, and latterly the Salvation Army. The pedestrian space (*centre*) included a now shamefully elusive amenity – a public toilet.

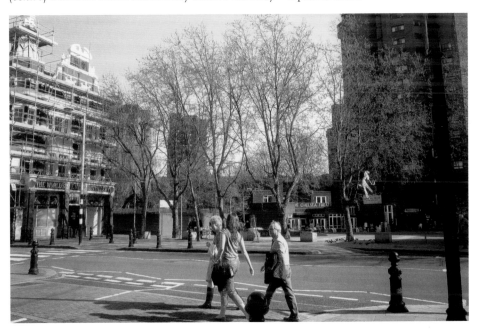

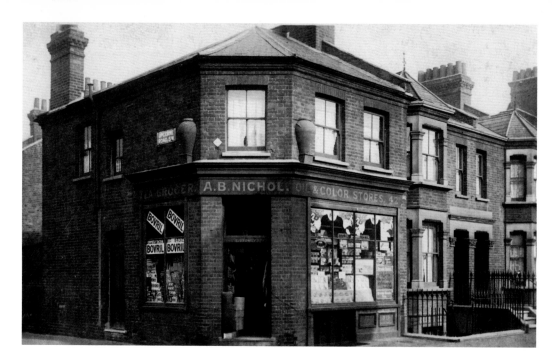

Arthur Nichol, Grocer and Oilman, No. 42 Burnaby Street by Upcerne Road, *c.* 1910
Arthur Nichol's shop was typical of many corner shops in London, but the style of building owed more to neighbouring Fulham than Chelsea. Posters for Bovril and Sunlight soap have a familiar look, but Epp's Cocoa disappeared long ago. Regeneration has given new life to this tranquil area where a new park compliments the chic family homes.

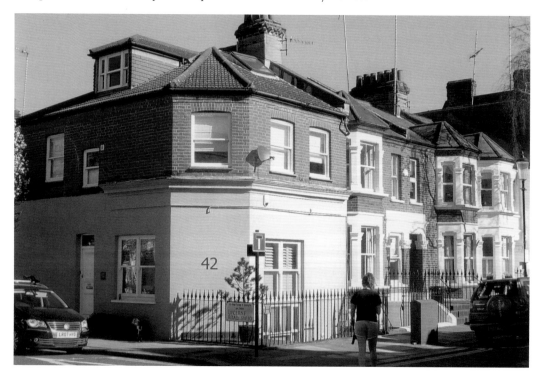

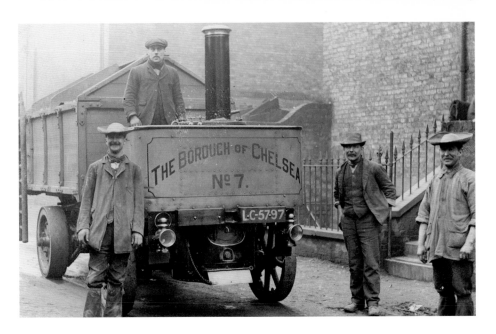

Chelsea Public Services: Refuse Collection, *c.* 1908, and Road Repairs, 1962
In horse-dominated Edwardian Chelsea, the borough's steam-driven refuse wagons made an imposing spectacle as they belched their way round the streets on collection day. The refuse was then transferred to barges at the borough's Thames-side wharf in Lots Road. The council was also committed to maintaining the borough's roads, greatly assisted in later years by this mighty road roller and its equally impressive driver, seen here during repairs to Pavilion Road.

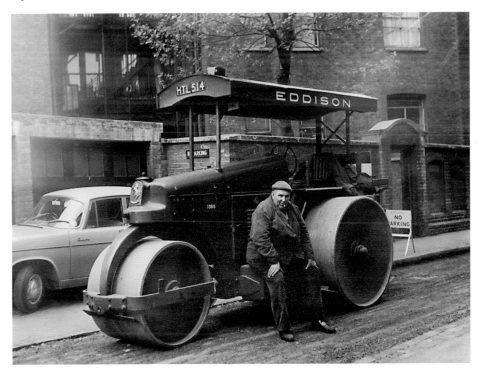

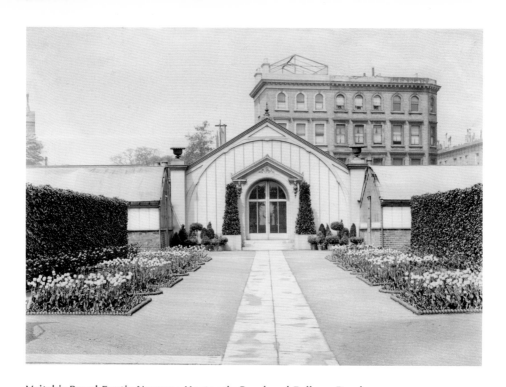

Veitch's Royal Exotic Nursery, Hortensia Road and Fulham Road, c. 1905

In its earlier days, Chelsea was noted for its market gardens and nurseries, but as the area took on a more urban look, they dwindled away. By the early 1900s only a couple remained in Western Chelsea. Of these, the Royal Exotic Nursery was set up in 1808; it was enlarged under the ownership of John Veitch in 1853, when its grounds ran from King's Road to Fulham Road. The nursery specialised in rare plants from around the world, and when the grounds were partly built over around 1903, a new road was named after one of the plants – 'Hydrangea Hortensia'. Part of Fulham Road can be seen here in the background.

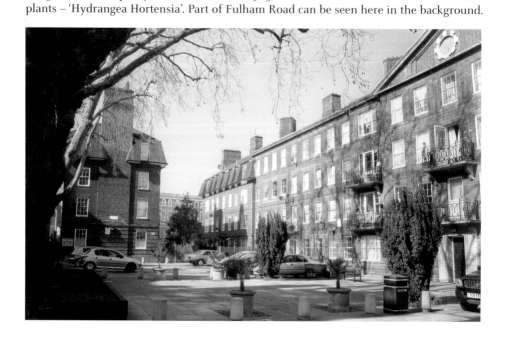

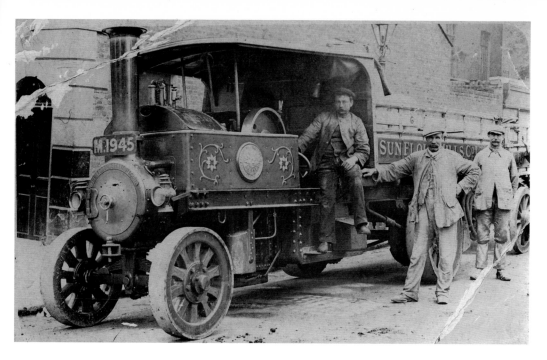

At Sun Flour Mill, Lots Road by King's Road, *c.* 1906

Much of Chelsea's industrial activity was concentrated along Lots Road, which backed onto the Thames and its tributary, Counter's Creek (Chelsea Creek). Other activities in Chelsea's industrial corner included yards for stone and coal merchants, and Cadogan Iron Works were also here. Sun Flour Mills' powerful steam lorry was well suited to its heavy haulage duties, but in an age when mechanical traction was uncommon, this noisy beast must have startled many a local horse.

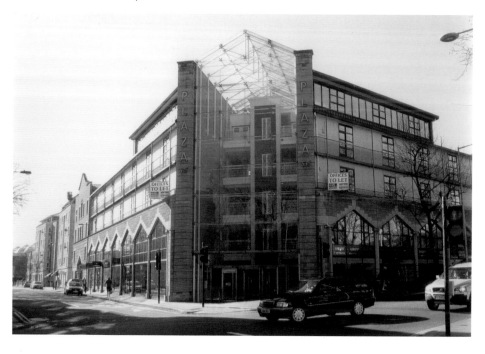

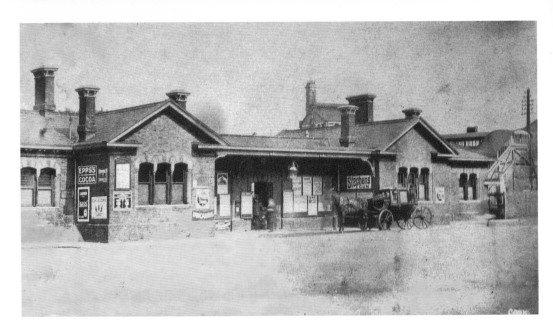

Chelsea & Fulham Station, Wandon Road, King's Road, c. 1906

Until 1940, it was possible to catch a train from here to a variety of London stations, and when Chelsea Football Club had home matches at their Stamford Bridge ground, it usefully served the supporters. The station opened in 1863, the West London Extension Railway's tracks straddling the Chelsea Fulham boundary. The main station buildings were on the Fulham side – Welch's Brewery in King's Road can just be spotted above the rooftops. War damage ended the station's passenger services, and after a period of dereliction, new housing arose on the site in 1958. However, trains do still run through the cutting here as part of London's orbital Overground network.